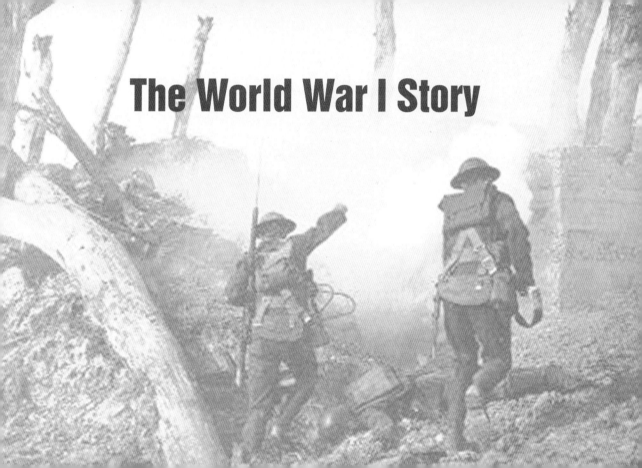

The World War I Story

The World War 1 Story

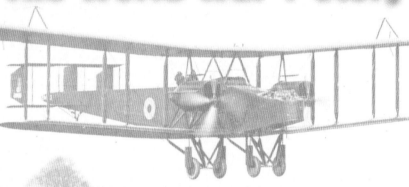

Chris McNab

The History Press

Published in the United Kingdom in 2011 by
The History Press
The Mill · Brimscombe Port · Stroud · Gloucestershire · GL5 2QG

British Library Cataloguing in Publication Data
A catalogue record for this book is available from the British
Library.

Hardback ISBN 978-0-7524-6203-5

Front cover image: A British casualty is carried from the
battlefield (Courtesy of Will Fowler). *Back cover*: A dramatic
image of US soldiers going into the attack in 1918. (Library of
Congress; www.gwpda.org/photos).

Typesetting and origination by The History Press
Printed in China

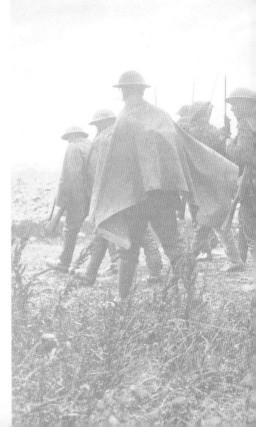

CONTENTS

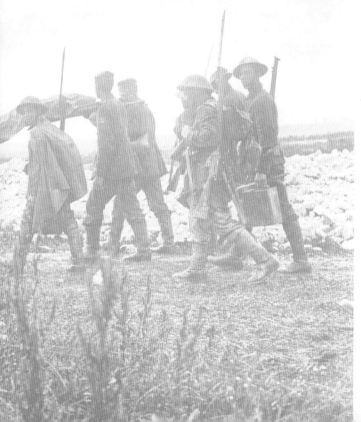

ACKNOWLEDGEMENTS

I would like to thank several individuals and organizations who have been central to the production of this book, particularly in terms of providing photographic material. The excellent collection of the Great War archive (www.gwpda.org/photos) provided the bulk of the images here, and it is a recommended source for all World War I historians. Thanks also go to Will Fowler, for sourcing additional images from his personal archive. Finally, as always, I appreciate the hard work of Jo de Vries of The History Press and thank her for her continual support and friendship.

All wars are tragic, but World War I seems especially so. The causes of this global conflict are difficult to understand from a modern perspective, and involve imperial ambition and decay, political posturing, an aggressive arms race and stubborn personalities. Essentially the great European powers mobilized and fought for what they believed would be rapid political and geographical gains. In the event, the war would last four years, cost millions of lives and lay the foundations for a later world war.

The origins of World War I are both complex and contentious. In the long-term, they begin with the Franco-Prussian War of 1870–71, which resulted in Prussia's crushing victory over France and the unification of the German state under Kaiser Wilhelm I. This war changed the entire political dynamic of Europe. Germany was resurgent and powerful, with a developing sense of nationalism. France was aggrieved, with an eye to revenge and to recovering the Alsace and Lorraine regions lost to the Germans. Negotiating this split were the other great European powers – the British and Austro-Hungarian Empires, the former still mighty on the world stage, the latter ethnically fragmented and faltering, and

Did you know?
Russia's population grew from about 85 million in 1875 to nearly 180 million in 1913, providing the manpower for the country's huge armed forces.

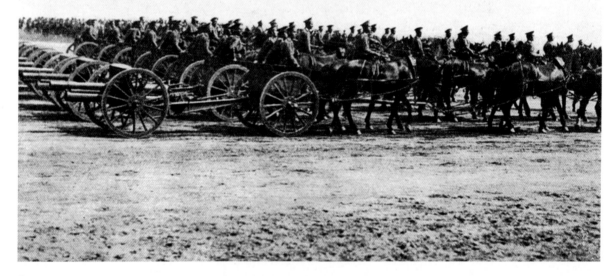

Russian horse-drawn field artillery passes in review for the French president, Raymond Poincaré, just prior to the beginning of World War I. (Histoire Illustrée de la Guerre de 1914, Tome Deuxième, Gounouilhou, Editeur, Paris 1914; www.gwpda.org/photos)

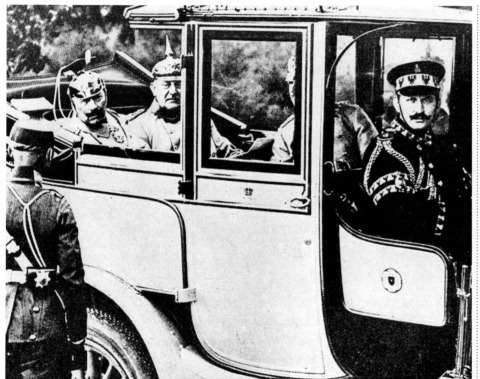

Kaiser Wilhelm II (left) seen here with General Helmut von Moltke, the German Army's Chief of Staff from 1906 to 1914. The failure of Moltke's health and of the offensive against the French in 1914 led to his replacement with Erich von Falkenhayn. (The Clash of Nations: Its Causes and Consequences, *Thomas Nelson & Sons, New York, 1914; www.gwpda. org/photos*)

the Russian Empire to the east, weakened by the Crimean War (1853–56) and the Russo-Japanese War (1904–05), but still with vast manpower resources.

Into this mix we also add the woes of the Ottoman Empire, centred on Turkey but with influence stretching through the Middle East and the Balkans. By the early twentieth century, this once-great empire was beginning its collapse, and the other imperial powers looked to fill the vacuum. For some the stakes were especially high. Russia in particular had serious concerns over who might gain control of the Turkish Straits linking the Aegean Sea to the Black Sea, through which flowed 90 per cent of Russia's grain exports and much other trade traffic. Austria-Hungary was particularly concerned about the future of the Balkans. The Austro-Hungarian Empire extended its control over millions of restless Serbs, Croats, Bosnians and Slovenians (collectively known as the 'South Slavs'), and Serbia itself, backed by Russia, encouraged the southern Slavs to break from Austria-Hungary and form a South Slav kingdom. Two wars in the

I look upon the People and the Nation as handed on to me as a responsibility conferred upon me by God, and I believe, as it is written in the Bible, that it is my duty to increase this heritage for which one day I shall be called upon to give an account. Whoever tries to interfere with my task I shall crush.

Kaiser Wilhelm II, 1913

Balkans in 1912 and 1913 also brought major victories for the Serbians, virtually driving the Turks from the Balkans and giving the Austro-Hungarians further cause for concern.

Behind this political turbulence, there were other overarching tensions within early twentieth-century Europe. Abroad, the great powers sought to create or maintain colonies in Africa, the Middle East and Asia, activities that brought clashes of armies and interests. At the same time, Europe became locked in a major arms race. Germany's attempts to invigorate her military power, plus Britain's launch of the 'Dreadnought' class of battleships in 1906 (which essentially made all other classes of battleship obsolete), resulted in a frantic scramble to build up the scale and power of armed forces. At the same time, the mainland European nations began constructing vast rail networks intended to deliver millions of troops to the frontlines of the future.

What essentially turned this crackling atmosphere into a global conflict was the system of European alliances forged since the end of the Franco-Prussian War. These alliances had a complex history, as each nation attempted to make the best pacts to promote mutual defence against perceived enemies. By 1914 the alliances had essentially settled into two blocs. On the one side was the Triple Alliance – Germany, the Austro-Hungarian Empire and Italy. (Germany had also built favourable relations with Turkey.) On the other side was the Triple Entente – Britain, France and Russia. The essence of these alliances was promises to assist friendly

states if attacked by those of the opposing bloc. It should be noted, however, that Italy was a very weak member of the Triple Alliance, and concluded secret agreements to avoid hostilities towards France if the French were attacked by Germany.

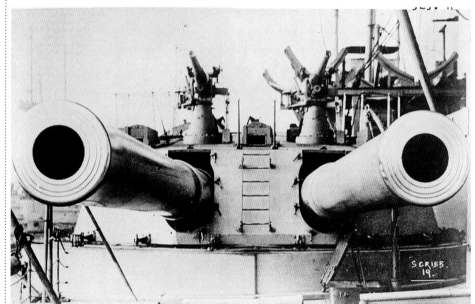

➤ A close-up view down the muzzles of HMS Dreadnought, the vessel that rendered all other capital warships obsolete and began a naval arms race in Europe. (Library of Congress (George Grantham Bain Collection); www.gwpda. org/photos)

The stage was set for bloodshed on an epic scale, but first it needed a spark. It came on 28 June 1914. While visiting Sarajevo in Bosnia, Archduke Franz Ferdinand, the heir to the Austro-Hungarian throne, was assassinated along with his wife by a Serbian nationalist, Gavrilo Princip. Incensed, and looking to subdue Serbia once and for all, despite the fact that Serbia had defence treaties with Russia, Austria-Hungary delivered a

Did you know?

The *Dreadnought* warship had ten 12in. (330mm) main guns, which could engage targets up to 11½ miles (18.6km) away. It also had an impressive top speed of 21 knots.

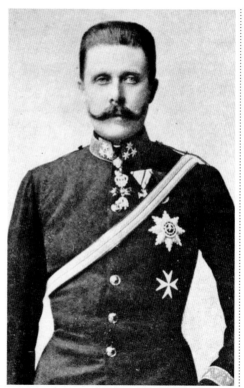

◄ *A portrait of the ill-fated Austrian Archduke Franz Ferdinand, assassinated on 28 June 1914 in Sarajevo by a Serbian nationalist. (History of the World War,* Vol. 1, *Doubleday, Page & Co., 1917; www.gwpda.org/photos)*

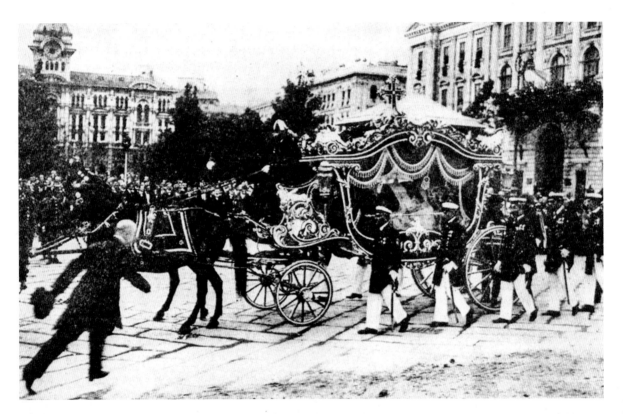

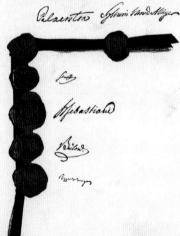

◀ The funeral procession of Archduke Franz Ferdinand. His killing served as the catalyst for World War I, leading Austria-Hungary to make war on Serbia and thereby triggering international alliances. (The Book of History – The World's Greatest War, Vol. XIIII, The Grolier Society, New York, 1920; www.gwpda.org/photos)

▶ A translation and facsimile of the 1831 treaty guaranteeing the neutrality of Belgium. Germany's invasion of Belgium in 1914 was a principal cause of Britain's entry into the war. (Courtesy of Will Fowler)

set of intentionally unacceptable demands, demands that would have effectively deprived Serbia of its sovereignty. When the deadline for accepting these demands lapsed, Austria-Hungary declared war on Serbia on 28 July 1914.

Now began a fast-moving political domino effect, as the alliance systems and other treaties came into play, impelled

This document is a translation and facsimile of signatures from the original treaty of 1831 guaranteeing the independence and neutrality of Belgium, which was confirmed by the six Powers in the famous treaty of 1839, the breaking of which by Germany is responsible for the present war with the British Empire.

The "Scrap of Paper"

ARTICLE II.

Her Majesty the Queen of the United Kingdom of Great Britain and Ireland, His Majesty the Emperor of Austria, King of Hungary and Bohemia, His Majesty the King of the French, His Majesty the King of Prussia, and His Majesty the Emperor of all the Russias, declare, that the Articles mentioned in the preceding Article, are considered as having the same force and validity as if they were textually inserted in the present Act, and that they are thus placed under the guarantee of their said Majesties.

ARTICLE VII.

Belgium, within the limits specified in Articles I., II., and IV. shall form an independent and perpetually neutral State. It shall be bound to observe such neutrality towards all other States.

PALMERSTON
British Plenipotentiary
SYLVAN VAN DE WEYER
Belgian Plenipotentiary
SENFFT
Austrian Plenipotentiary
H. SEBASTIANI
French Plenipotentiary
BÜLOW
Prussian Plenipotentiary
POZZO DI BORGO
Russian Plenipotentiary

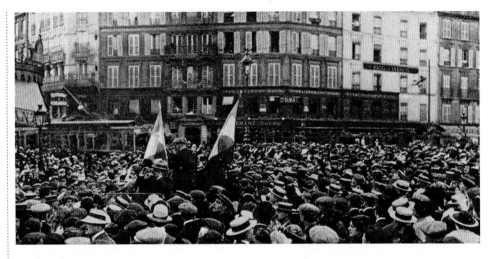

▶ Ready for war. French crowds gather in celebration as thousands of young volunteer soldiers head to a Paris railway station for deployment to the new war against Germany. (New York Times, 30 Aug 1914 (International News Service); www.gwpda. org/photos)

also by Germany's desire to launch a war before Russia could fully stir itself. As Russia mobilized, Germany declared war on Russia on 1 August, an act that in turn brought France into war with Germany on 3 August. Britain was also sucked into the conflict, not only through its treaties with France but also by its commitment to protect the neutrality of Belgium, which the Germans invaded on 4 August.

Through a mixture of failed diplomacy, big egos, sabre rattling and long-standing tensions, Europe had plunged itself into war in just eight days.

Even before war began, Germany already had a plan of how it aimed to win just the type of two-front European conflict which it now faced. It was known as the Schlieffen Plan, and was developed by Alfred von Schlieffen, the German Chief of Staff between 1891 and 1906. In broad outline, it envisaged the German Army driving in force through neutral Belgium and Luxembourg and into northern France, therefore bypassing the strong French fortifications along the Franco-German border. It would then swing south, encircling the French armies and taking Paris. Speed was of the essence to beat Russian mobilization, and it was predicted that France would quickly fall, thereby allowing German forces to redeploy rapidly to the Eastern Front.

A slightly modified version of the Schlieffen Plan was put into action on

An emotionally manipulative poster encourages British enlistment with the strapline 'Duty and honour bid us part'. Those who did not volunteer for armed service faced social hostility and accusations of cowardice. (Courtesy of Will Fowler)

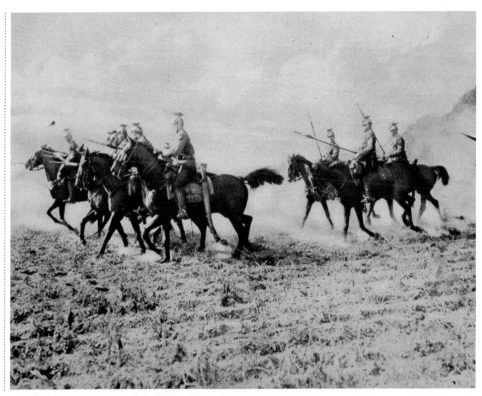

German Uhlan cavalry advance, with their lances at the ready. Such stirring visions of the nineteenth century did not last long in an era of machine guns and artillery. (War of the Nations, *New York Times* Co., New York, 1919; www.gwpda.org/photos)

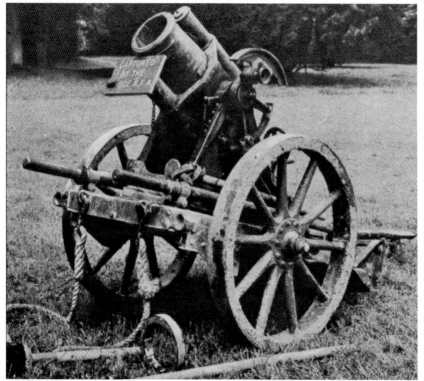

◁ A captured German trench mortar. German forces had superiority in mortar firepower over the Allies at the beginning of the war, the weapons proving ideal for providing rapid short-range support fire to infantry attacks. (War of the Nations, *New York Times Co., New York, 1919; www.gwpda.org/ photos)*

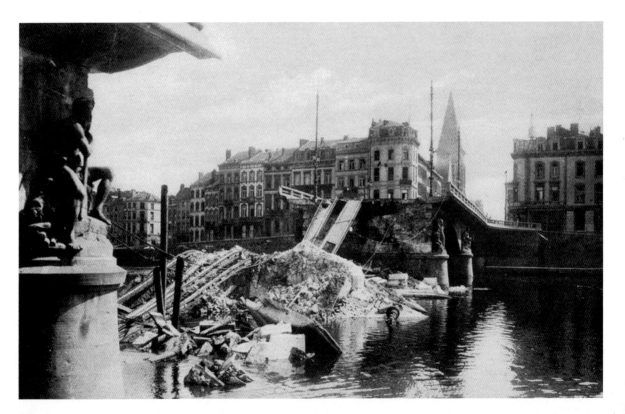

4 August 1914. Five German armies, under the overall command of Chief of Staff Helmuth von Moltke, surged into Belgium and Luxembourg. German confidence was high. It had an army of 1.7 million men; France had about 1.1 million mobilized at the beginning of the war and Britain would initially contribute about 100,000 men in the British Expeditionary Force (BEF), but standards of German training were superior. The German Army also had good equipment, particularly in terms of heavy artillery and mortars.

The German advantages were initially expressed in strong advances. Belgium itself, with a total army of 117,000 soldiers, was no buttress against three German armies (1st, 2nd and 3rd) totalling 750,000 men. The fortresses that ringed the city of Liège were subdued by pounding German artillery – the last fortress fell on 16 August – and by 20 August the Germans were moving through Brussels and beginning the swing southwards.

The French, under the command of General Joseph Joffre, were wrong-footed by their own pre-war (1913) plan, known as Plan XVII, and based on a major counter-offensive through Alsace and Lorraine. When it was launched, the attack made some initial decent gains, but the series of

The sad remains of the Pont des Arches bridge in Liège, Belgium. The bridge was blown up by Belgian forces in a vain attempt to slow down the German advance from the east. (War of the Nations, New York Times Co., New York, 1919; www.gwpda.org/photos)

pushes were blunted and stopped by four German armies east of Verdun and Nancy, and by the end of their first month of fighting the French had lost 75,000 dead and 200,000 through wounds or capture. Furthermore, by focusing on the front through and south of the Ardennes, they had exposed their flank to the Germans coming down from the north.

Britain was now also in the war. The BEF under Sir John French, just five infantry divisions strong at this stage, had arrived in France on 14 August, and in late August only they and the French 5th Army stood in the immediate path of two German armies assaulting the Franco-Belgian border. The first clash between German and British troops came at Mons on 23–24 August, in which the British initially inflicted heavy casualties on the enemy via blistering rifle and machine-gun fire, but were eventually ousted by German gunnery and manpower. French opposition was also quashed, and the Germans crossed the border and moved towards Paris.

The description above suggests German invincibility, but such was far from the case. In fact, German forces were now beginning to suffer from logistical overreach. Their advance meant that by the end of August

The enemy started to advance in mass down the railway cutting, about 800 yards off, and Maurice Dease fired his two machine-guns into them and absolutely mowed them down. I should judge without exaggeration that he killed at least 500 in two minutes.

Lieutenant K. Tower, Royal Fusiliers, 1914

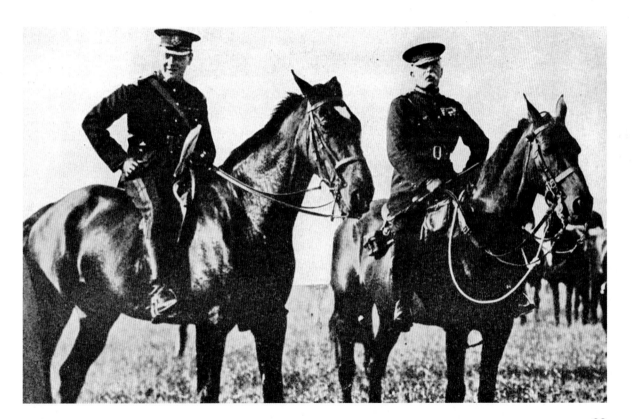

23

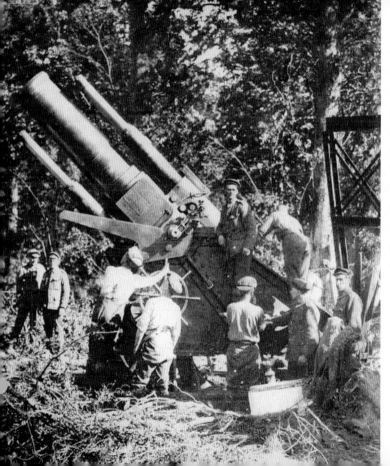

the nearest German-controlled railheads to the frontline were 85 miles (135km) away. Overworked horses – the main method of hauling heavy equipment and supplies – were also dying in huge numbers from exhaustion and poor diet. Ammunition for the field and heavy guns was running low, and manpower had been peeled away from the southern advance to cope with remaining challenges further north, such as operations against Antwerp (the city fell on 10 October).

Did you know?

Germany transferred troops to the Western and Eastern fronts via six main railway lines. The railways meant that Germany could mobilize its armed forces at four times the speed it could in the 1870s.

By the end of the first week of September, therefore, the offensive had effectively run out of steam, and the British and French had regrouped around Paris.

Critically, the German 1st Army – the westernmost German force – had also swung east of Paris to keep in contact with its neighbouring 2nd Army, exposing its

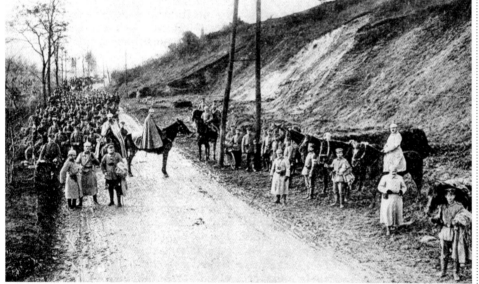

◄◄ A British howitzer prepares to fire. This particular gun is the Mk 1 9.2in heavy siege howitzer, which could hurl a shell weighing 288lb (131kg) to a distance of 10,000yds (9144m). (Illustrated War News, Vol. 1, Illustrated London News and Sketch, London, 1916; www. gwpda.org/photos)

◄ Columns of German infantry advance into France in 1914. Although rail networks enabled initial mobilization and deployment to the front, the infantry advances themselves were made by foot and horse. (The Book of History – The World's Greatest War, Vol. XIIII, The Grolier Society, New York, 1920; www.gwpda. org/photos)

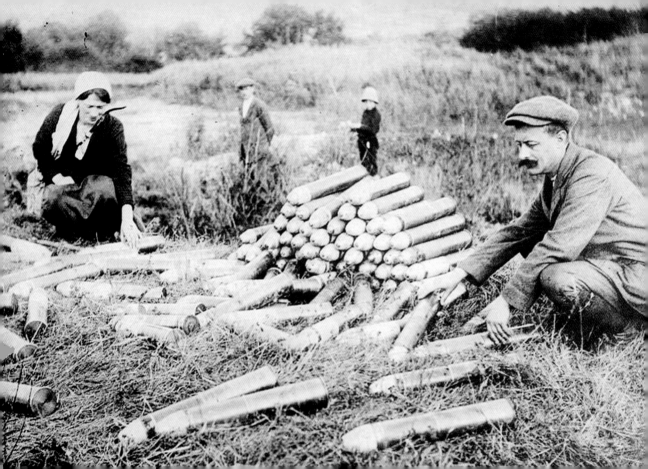

flank to a counter-attack. What became known as the Battle of the Marne began on 5 September. In a broad series of attacks, the French and British not only stopped the German momentum, but also saved Paris and split the German 1st and 2nd Armies. In response the Germans were forced to retreat back to the River Aisne.

The Germans had begun to put down defensive trench systems as the front became increasingly static; Allied attempts to dislodge the Germans from these positions on the Aisne between 13 and 27 September resulted in little but a high death toll, so the Allies too began to entrench. To the north, however, there developed the 'race to the sea', each side's attempt to outflank the other. Neither side succeeded, although there was plenty of blood spilt in the attempt. One of the most serious threats for the Allies was the German Flanders offensive, launched by the new Chief of Staff Erich von Falkenhayn (von Moltke had gone after the Battle of the Marne), which culminated in the First Battle of Ypres. Ypres was a British-held salient around the eponymous Belgian town, and the site of three major battles during the war. The cost of this battle, which petered out in bad weather in late November, was 250,000 French, British and German casualties.

Did you know?

In total, France mobilized 84 per cent of its available manpower for war service between 1914 and 1918, a total of about 4 million men, although even these numbers were insufficient to cope with losses and strategic demands.

◄ Civilians collect up piles of ammunition abandoned by German forces following the French victory at the Battle of the Marne, the clash that saved Paris from German capture. (Library of Congress (George Grantham Bain Collection); www.gwpda. org/photos)

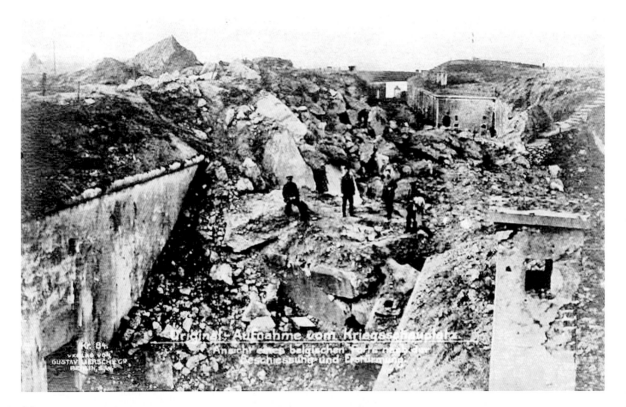

Original-Aufnahme vom Kriegsschauplatz
Ansicht eines belgischen Forts nach der
Beschiessung und Erstürmung.

Kr. 84.
VERLAG VON
GUSTAV MERSCH & Cº
BERLIN, S.W.

28

The end result of the race was the creation of a virtually static frontline that ran from the coast of Flanders in the north to Alsace in the south. This frontline, inscribed into the soil by vast networks of trenches and bunkers, was to become the battleground on the Western Front for the next four years. While the fighting for the Western Front was playing out, equal drama and bloodshed was occurring on the Eastern Front. Austria-Hungary, its armed forces led by Count Francis Conrad von Hötzendorf, faced Serbia to the south and a Russian threat to Galicia to the east. The first Austro-Hungarian offensive into Serbia was a disaster. Outclassed and outmanoeuvred by the Serbians, the Austro-Hungarian army suffered 40,000 casualties, yet they persisted in costly offensives even as events elsewhere drew their attention.

On 17–20 August, in an attempt to open the two-front war Germany had sought to avoid, the Russians invaded East Prussia with two armies, hoping to surround and crush the German 8th Army, commanded by Paul von Hindenburg and Erich Ludendorff (the latter was the army's Chief of Staff). Although the initial German attempts to repulse the invasion were defeated, Hindenburg nevertheless kept his cool and deployed his available forces south to attack the Russian southern flank. The tactic paid off, aided by poor coordination between the Russian armies, and at the Battle of Tannenberg between 23 and 31 August the Russian 2nd Army was enveloped and crushed, losing three corps' worth of men. A subsequent victory against the 1st Army in the First Battle of the Masurian Lakes

◀ The new reality of warfare. This image shows the devastation wrought by German artillery against one of the powerful Belgian frontier forts at Liège. Static positions became vulnerable to reduction by long-range gunnery. (Walter Maier (grandson); www.gwpda.org/photos)

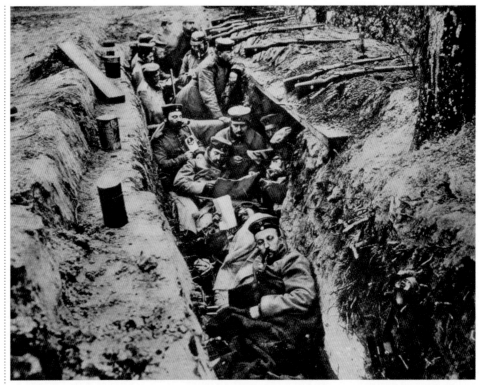

➤ *German troops unwind in a trench in 1914. By the end of the year trench systems demarcated the entire Western Front. The Germans proved particularly adept at their construction, especially on underground bunkers. (*War of the Nations, *New York Times Co., New York, 1919; www.gwpda. org/photos)*

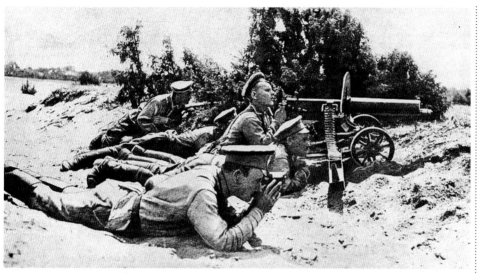

(9–14 September) ensured that by mid-September the Russians had been driven out of East Prussia.

Things were going better for the Russians further south, against the beleaguered Austro-Hungarians. An Austro-Hungarian offensive into southern Poland from Galicia met with initial success, then failure and a retreat of more than 100 miles (160km). Conrad had handled his strategy

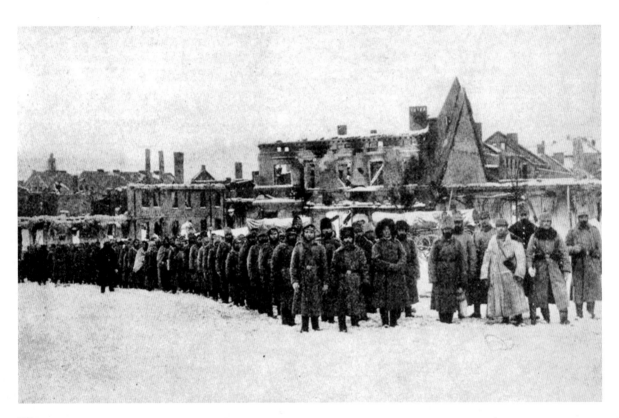

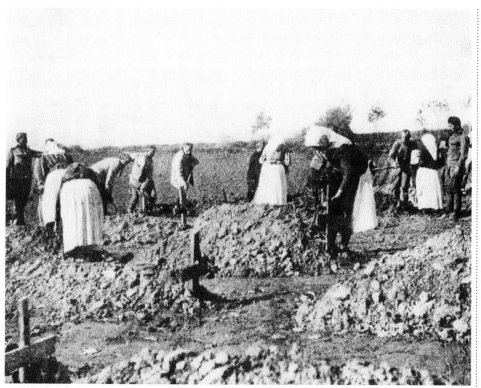

◀◀ *The Russians experienced some catastrophic defeats in their first months of combat on the Eastern Front. Here we see some of the thousands of Russian prisoners taken during the Battle of the Masurian Lakes, September 1914. (*The Book of History – The World's Greatest War, *Vol. XIII, The Grolier Society, New York, 1920; www.gwpda.org/photos)*

◀ *Serbian women undertake the solemn task of burying the dead after a battle. The Austro-Hungarian invasion of Serbia was a disaster, and needed German support to produce victories. (*New York Times, *02/14/1915; www. gwpda.org/photos)*

disastrously, and not for the last time in the war the Germans had to come to his assistance to prevent their ally's collapse.

Between October and December 1914, the Eastern Front was in almost constant movement, with both sides launching offensives. A German drive against Warsaw was stopped and put into reverse, while the Austro-Hungarian forces actually managed to inflict a serious defeat on Russia on 5–17 December at the Battle of Limanova, and prevented the Russians taking Cracow. Its assaults into Serbia, however, once again ended in ignominious failure – the total Austro-Hungarian cost of the Serbian offensives was 227,000 casualties.

Europe entered its first winter of the new war with an emerging sense of realism about what it faced. The 'over by Christmas' optimists on both sides were

> For a young man who had a long and worthwhile future awaiting him, it was not easy to expect death almost daily. However, after a while I got used to the idea of dying young.
>
> Reinhold Spengler, a German volunteer soldier

proven wrong, and the scale of slaughter that could be wrought by modern small arms and artillery was sobering. The Western and Eastern Fronts were also very different in nature – the former locked in lines of muddy trenches, the latter seeing frequent exchanges of territory, and big advances and retreats. Yet these were early days. The war's consumption of men and materiel, and its geographical extent, were to expand significantly.

By 1915, it was clear to the combatants that manpower and material strength were going to be the foundations of victory. Armies suddenly had to acquire millions more men for the war, and did so through a mixture of volunteers and conscription. In Britain, for example, a nationwide enlistment programme headed by the Secretary of State for War, Field Marshal Lord Kitchener, brought 1 million volunteers into the ranks by January 1915, and 2.5 million by the end of the year. Yet such was the voracity of the fighting that conscription was still implemented in May 1916.

The high human cost of the fighting was partly because the conflict sat on the dividing line between old imperial ways of war and new industrial technologies of destruction. The fondness for charges by

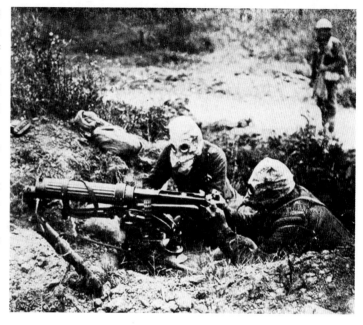

A British Vickers machine-gun team put down fire on the Western Front, while wearing gas masks to protect them from gas attacks. The Vickers had a lethal range well in excess of a mile. (The Battle of the Somme: The First Phase, Thomas Nelson & Sons, London, 1917; www.gwpda.org/photos)

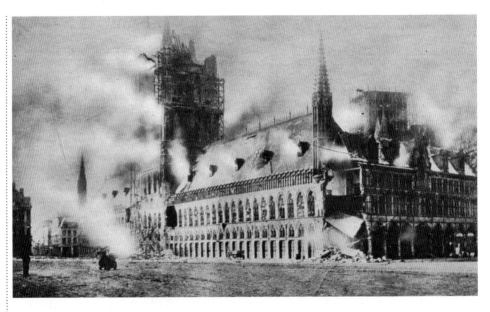

infantry and cavalry across open ground – on the Western Front the 'no-man's-land' between trenches – became lethal in the face of rifles and machine guns that had accurate ranges measured in hundreds of yards, and the possibilities of close-quarters valour were therefore marginal. Artillery was also powerful and accurate,

and meant that indirect fire could inflict a withering attrition on distant enemies, or bludgeon them with storms of fire at the opening of an offensive. At the same time, communications between frontline and command post were still extremely poor, making real-time command decisions almost impossible. Such factors were a breeding ground for slaughter on a vast scale.

The war was also expanding territorially. On 29 October, Turkey had entered the war on the side of Germany and Austria-Hungary, putting the Turkish Straits under the control of the Central Powers. During the winter, Enver Pasha, the Turkish War Minister and Ottoman commander-in-chief, launched an offensive against the Russians in the Caucasus, and so early in the new year Russia requested help from her allies. The initial response from Britain, championed by the then First Lord of the Admiralty Winston Churchill, was to send battleships into the Dardanelles (one of

Did you know?

At the battle of Mons in 1914, the British infantrymen fired so quickly with their .303in. Short-Magazine Lee-Enfield (SMLE) rifles that German soldiers believed in many instances they were faced with machine guns.

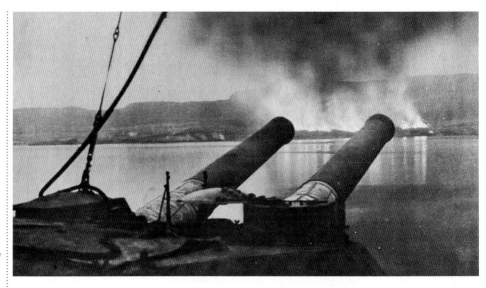

➤ British stores burn along the Dardanelles coastline following the Allied withdrawal from Gallipoli in late 1915. This view is from the battleship HMS Cornwallis. (War of the Nations, *New York Times Co., New York, 1919; www.gwpda.org/photos)*

➤➤ British Empire and Commonwealth soldiers were deployed around the world. Here we see Australian engineers constructing a bridge over an irrigation channel in the shadow of the pyramids at Giza. (New York Times, *03/28/1915; www.gwpda.org/photos)*

the Turkish Straits, the other being the Bosphorus) to hammer away at Turkish forts. This action was roughly handled by the opposition (five battleships were sunk by coastal fire and German U-boats), so instead five divisions of British and Commonwealth forces (principally New Zealanders and Australians) were landed on the Gallipoli Peninsula on 25 April. This landing, and a subsequent one at Suvla

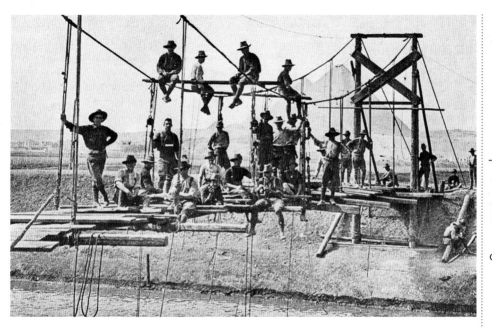

Did you know?
The soldiers of the Australian and New Zealand Army Corps – known as ANZACS – eventually numbered about 500,000 men, a large percentage of the countries' total combined populations of only 6 million.

Bay on 6 August, had the odds stacked against them from the start. The forces were confined on narrow beachheads, shelled constantly, and frontal attacks on well-emplaced Turkish positions brought horrendous casualties, particularly at the

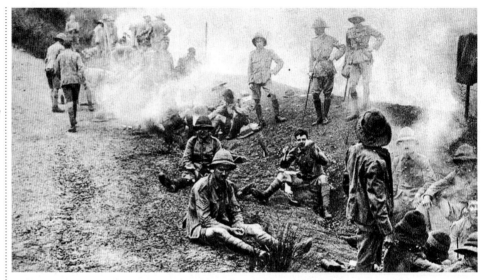

British troops in German East Africa prepare for a meal. The African theatre was very much a side event compared to what was happening in mainland Europe, but the campaigns there were still hard fought. (Illustrated War News, Vol. 1, Illustrated London News and Sketch, London, 1916; www.gwpda.org/ photos)

infamous 'ANZAC Cove' area held by the Antipodean soldiers. Eventually the Gallipoli campaign was recognized as pointless, and the Allied troops were evacuated in December 1915 and January 1916.

Elsewhere, the war did not go well for Turkey. The winter campaign against the Russians in the Caucasus resulted in 90,000 Turkish dead, 30,000 of whom froze to death in the appalling sub-zero conditions.

Subsequent Russian offensives in 1915 and 1916 drove deep into the Ottoman heartland. Furthermore, in January 1915 the Turks invaded northern Persia, garrisoned by Russia (Britain guarded southern Persia), an effort that also ended in defeat. The

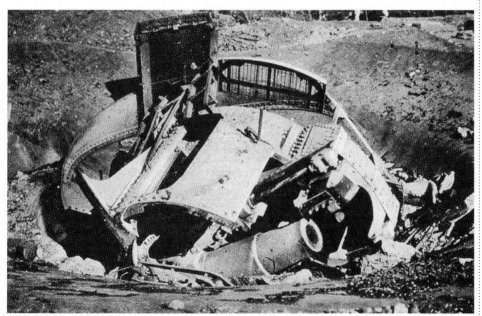

A wrecked German gun emplacement at Tsingtao, China, destroyed by an overwhelming force of Japanese Army troops in the autumn of 1914. (War of the Nations, New York Times Co., New York, 1919; www.gwpda. org/photos)

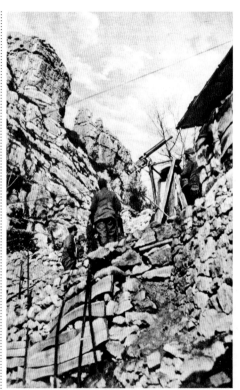

This view of an Italian machine-gun position gives a good impression of the challenges of high-altitude combat on the Isonzo Front. In the winter, thousands of troops on both sides suffered from frostbite and hypothermia. (War of the Nations, New York Times Co., New York, 1919; www.gwpda.org/photos)

Did you know?

One of Paul Lettow-Vorbeck's tactics was to draw enemies into areas riddled with tsetse flies. There the enemy's horses would die from disease, leaving the soldiers vulnerable to being picked off by German ambushes.

next target for the Turks was the British-controlled Suez Canal. A well-executed march across the Sinai Desert by the Turkish 4th Army meant the Turks reached the Canal by 3 February, but the British in Egypt were waiting – it was hard to keep secret an entire army marching across a table-top flat landscape. A defensive battle by the British put paid to Turkish forces'

immediate Egyptian ambitions. In balance, a British attempt to capture Baghdad was defeated by a Turkish force at Ctesiphon, and the Turks captured the town of Kut after a siege that even saw British and Indian troops starving to death.

The war also spread out to colonial possessions in Africa and the Far East, although the numbers of men involved in the fighting were tiny compared to the grand scale of events in Europe. In Africa, British, French and African troops took Togoland, Cameroon and Southwest Africa from the Germans in a series of tough campaigns, disease delivering more casualties than fighting. In German East Africa, however, the remarkable resistance of General Paul Lettow-Vorbeck and a few thousand men, who used mobility and guerrilla tactics to prevail, ensured that the region remained unsubdued by the Allies for the duration of the war.

Much further afield, the early months of the war brought actions against German possessions in the Pacific, which were mainly held as projections of German maritime power. One of the most significant outposts was Tsingtao, China, on the Shantung Peninsula, a base for Germany's East Asiatic Squadron. British and Commonwealth naval presence in the Pacific was limited, so Britain turned to the assistance of a treaty ally, Japan. Japan obligingly declared war on Germany on 23 August 1914, and on 2 September landed a force of 60,000 men on the peninsula. Tsingtao itself came under general attack on 16 October, and by 7 November its garrison had surrendered. Further east and south, Germany also lost

Did you know?
On Christmas Day 1914, an unofficial truce took place on many parts of the Western Front. Soldiers even climbed out of their trenches and exchanged gifts with the other side.

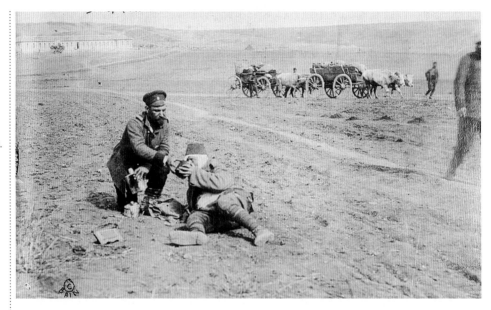

its possessions in Micronesia, the Marshall and Caroline Islands, Samoa, German New Guinea, the Bismarck archipelago and the Solomon Islands.

Many of these far-flung engagements had little effect on the overall development of the war. The same, however, cannot be said for what occurred on 23 May 1915.

On that day Italy showed its true hand by declaring war on Austria-Hungary. The previous April, Italy had signed a secret treaty with the British and French, in which Italy's allegiance was bought with the promise that it could lay claim to Italian-speaking parts of the Austro-Hungarian Empire. The treaty may have been secret, but the Central Powers knew what Italy was up to, and prepared its cross-border defences appropriately.

The problem for Italy was that the battlefront between Italy and Austria-Hungary was an inhospitable, mountainous terrain, with offensive options limited to certain passes. Fighting began in June, and included some high-altitude victories by Italian Alpine troops, but the main thrusts were concentrated through the Julian Alps on what was known as the Isonzo Front. The fighting on this front, which produced ten major battles and numerous smaller engagements, was a matter of awful attrition in a treacherous landscape. The Italian efforts to break through on the Isonzo River were all repulsed by the Austro-Hungarian forces, albeit with heavy cost to both sides. Not until 1916 did an offensive, this time by Austria-Hungary, bring any significant movement to the front.

The tragedy of World War I is visibly represented by the trench systems that came to define the landscape of the Western Front. Initially the trenches were improvised affairs – no-one expected to be in them for very long – scraped out with spades and picks. In 1915, however, the trenches became increasingly sophisticated, with a permanent feel. Both the British and the Germans developed complex parallel trench systems, consisting of front, reserve and support trenches (the German networks tended to be broader than the British equivalents), substantially constructed using timber, metal sheeting and sandbags.

Underground bunkers protected soldiers from both the weather and shellfire; the Germans were masters at keeping their machine guns and gunners safe below ground in heavily protected concrete bunkers, ready to emerge once a bombardment had ceased.

Trench warfare inevitably favoured the defence. Typically, rival frontline trenches were separated by 100–400yds (90–365m) of shell-blasted no-man's-land. Crossing this short expanse of ground meant exposing yourself to gales of accurate machine-gun,

When they took the Roll Call after Loos those not answering, their chums would answer: Over the Hill. Also when the post and parcels that had arrived from Home were being dished out after Loos, we new arrivals got share of the parcels that were meant for the boys who got killed.

Private Stewart Carson, following the Battle of Loos, 1915

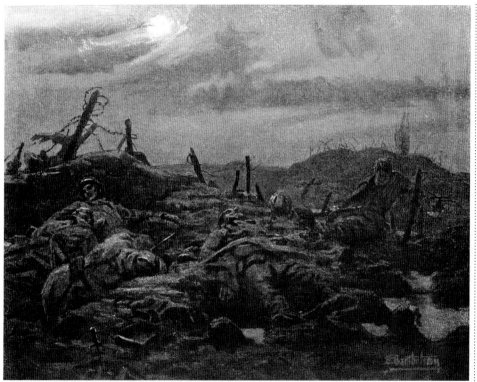

A painting disturbingly portrays the reality of combat on the Western Front. Here a French soldier struggles through a landscape of death, mud, shellfire and barbed wire. (Courtesy of Will Fowler)

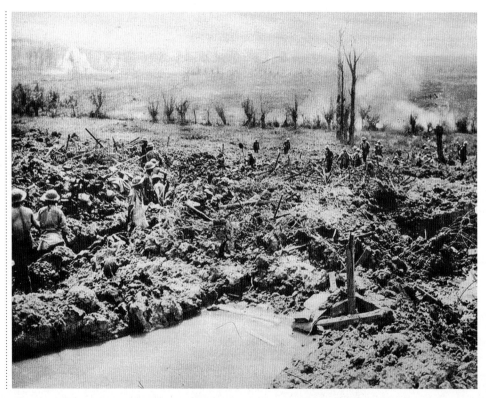

*British sappers attempt to construct a communications trench in the blasted landscape. High water tables created severe problems with drainage, and meant soldiers often had to move through ankle-deep mud even inside a trench. (*War of the Nations, *New York Times Co., New York, 1919; www.gwpda. org/photos)*

A British casualty is carried from the battlefield. Those British soldiers who died in France were rarely repatriated for burial, instead being interred in mass graves behind the front. (Courtesy of Will Fowler)

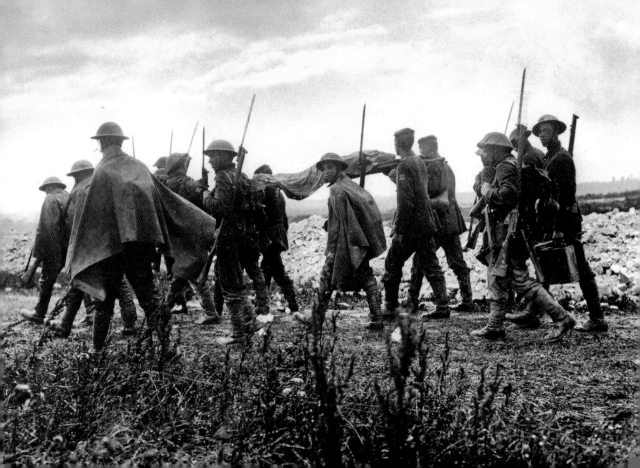

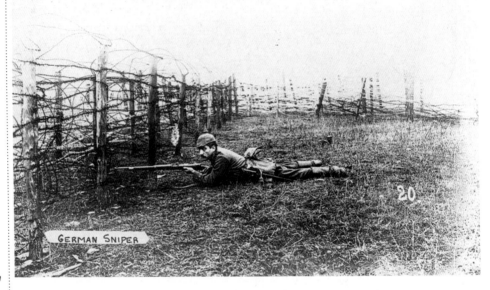

A German sniper lurks behind a barbed wire belt, looking for tactics. This photograph provides a graphic illustration of the tactical challenges presented by barbed wire systems. (Library of Congress; www.gwpda.org/photos)

A German artillery barrage lights up the night sky. Artillery's main purpose was to suppress and attrite the enemy prior to an infantry assault, although it rarely managed to destroy a defence before the infantry attacked. (History of the World War, Vol. 3, Doubleday, Page & Co., 1917; www.gwpda.org/photos)

GERMAN SNIPER

rifle and artillery fire, and if you actually made it to the enemy trenches you would have to negotiate twisted spirals of barbed wire. Should you in fact make it beyond the barbed wire, nightmarish hand-to-hand combat awaited you.

The main effort applied to breaking the defence was artillery fire, and lots of it. Even

today, certain areas of France and Belgium have landscapes totally reshaped by the volume of artillery fire used by both sides. Artillery was certainly the big killer of World War I, but it was not generally decisive in battle. Trenches could be stubborn protectors of troops, and only a direct or near-direct hit on a trench could inflict serious casualties. (Mortars were more useful at short ranges, because of their steep angle of descent.) Moreover, millions of shells fired during the war did not explode on impact, either because they were duds or they simply buried their way into soft, muddy earth. And that was if shells were available. In 1915, all the combatants faced a munitions crisis, in which they were literally running out of shells. It was quickly recognized that the war was as much a matter of industry as combat, and governments

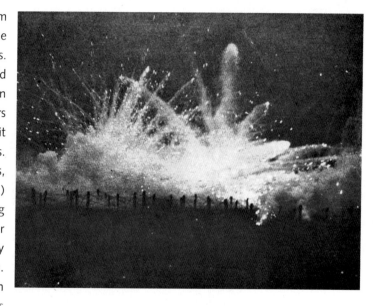

began a much more direct management of their industries and workforces. Only once industry was fully geared for war was the shell shortage solved.

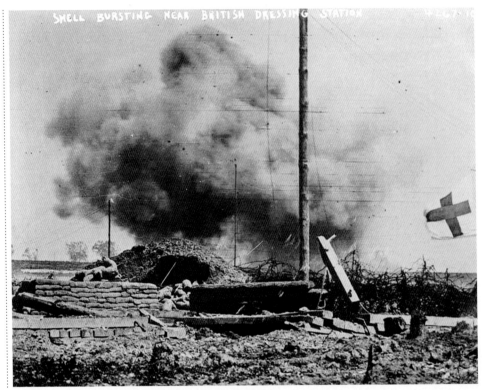

A shell bursts near a British dressing station. The British Army operated a system of regimental first aid posts for immediate treatment, after which the casualty was passed back through a series of more advanced aid stations and military hospitals. (Library of Congress (George Grantham Bain Collection); www.gwpda.org/photos)

In terms of strategy and tactics, the Western Front settled into a grim pattern of behaviour between the end of 1914 and the penultimate year of the war. One side would launch a thunderous bombardment against the enemy lines, to suppress and kill the defenders. When it ceased, the infantry would attack, lose heavily in the assault, and either make inconsequential gains for huge casualties or end up back where they started. Cavalry would clutter up the rear areas, waiting for a breakthrough that usually never came. Some sophistication was later introduced, such as using artillery 'rolling barrages' that steadily moved forward a short but safe distance in front of advancing infantry, giving the defenders little time to recover before the attackers were upon them. Yet essentially trench warfare was a matter of attrition, a grinding mill for men and material set in place by limited tactical horizons, notions of martial tradition, the power of modern weaponry and poor communications systems.

In 1915, both sides launched several major offensives in an attempt to break the deadlock. A British attack against the shattered village of Neuve Chapelle on 10 March secured the objective and made decent initial advances, but (in what would become a typical pattern) ran out of steam

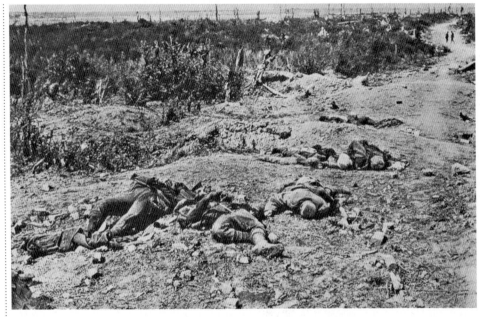

*German troops lie dead on a road near Moslains, France. Death from artillery fire could be sudden and unexpected, and it was the cause of approximately 60 per cent of the war's casualties. (*War of the Nations, *New York Times Co., New York, 1919; www.gwpda. org/photos)*

through casualties and a failure to deploy reserves in a timely fashion. Anglo-French plans to attack the strategically important Aubers and Vimy ridges in Artois were then disrupted by a major offensive by the German 4th Army against the Ypres

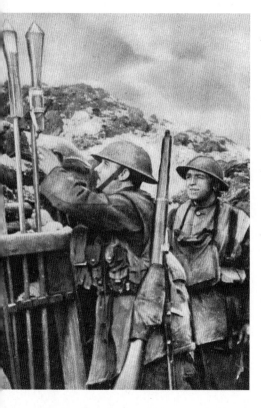

salient. The Second Battle of Ypres was notable for the war's first serious use of poison gas – the Germans released 5,730 cylinders of chlorine gas against the French sector trenches, creating casualties and panic in the French lines. For a time, the German offensive looked as if it could achieve a decisive breakthrough, forcing a gap between French and British/Canadian forces and putting the Allies into a retreat from 1 May. Yet eventually the Allied defence solidified, and by the end

> The whole earth is ploughed by the exploding shells and the holes are filled with water, and if you do not get killed by the shells you may drown in the craters.
>
> German infantryman, Hans Otto Schetter

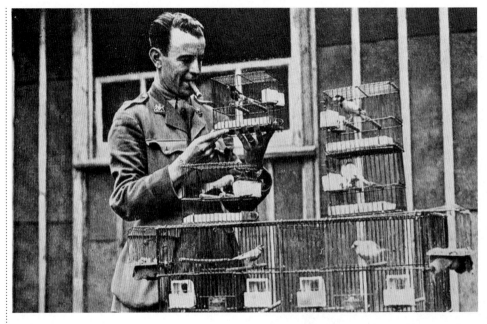

*Canaries are especially sensitive to poisonous gases, succumbing to the effects well before humans. The birds here were used by British troops to detect gas attacks. (*Birds and the War, *Skeffington & Son, London, 1919; www.gwpda.org/photos)*

of May the offensive had petered out. The price was 58,000 Allied soldiers, and 38,000 Germans.

Germany was now weakened on the Western Front, especially as troops were being siphoned off to support fighting

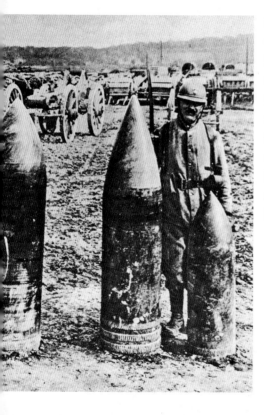

on the Eastern Front, and for the rest of the year the Allies took the offensive initiative. Offensives in the spring and autumn in Artois and Champagne both made limited gains for high casualties, despite the fact that in the second half of the year the Allies had increased troop numbers and the weight of artillery used in their attacks. One point of note is that at the Battle of Loos, launched by the British on 25 September in Artois (the

A French soldier stands by three huge artillery shells, from left to right: 420mm, 360mm and 305mm. Such shells were fired only from the heaviest siege guns. (Illustrated War News, Vol. 1, Illustrated London News and Sketch, London, 1916; www.gwpda.org/photos)

Did you know?

Mustard gas was one of the most destructive gases used in the war, causing respiratory failure, blindness and skin blistering. It was almost odourless, so the victim could breathe it for long periods without knowing.

General Erich von Falkenhayn, who was Chief of German General Staff between September 1914 and August 1916. Falkenhayn's focus was primarily on the Western Front, where he hoped to break the British and the French. (War of the Nations, New York Times Co., New York, 1919; www.gwpda.org/photos)

The fierce battle around Verdun included urban combat. Here French soldiers are engaged in house-to-house fighting, using their 8mm Lebel rifles with bayonets fixed for close-quarters action. (New York Times, 03/19/1916; www.gwpda.org/photos)

French 2nd Army made a simultaneous thrust in Champagne), the British also used poison gas. The gas killed or wounded some 600 Germans, and it aided an initial British advance of 2.2 miles (3.6km) – spectacular by World War I standards. The Germans, however, reconstituted their lines and brought up reserves faster than the attackers could deploy theirs (a familiar problem of offensives on the Western Front). The resulting slaughter was fearful

Did you know?
Early gas protection systems consisted of nothing more than pieces of cloth soaked with urine or water. By 1917, gas masks had advanced to including gas-neutralizing chemicals.

– 50,000 British casualties by the time the offensive stopped on 14 October, including 6,000 dead in just two days.

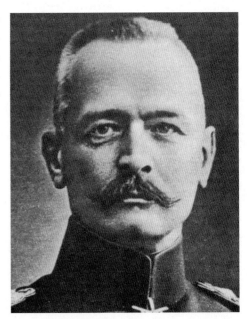

Did you know?

Belts of barbed wire were huge obstacles to assaulting infantry. Typical German barbed-wire belts could be up to 100ft (90m) deep, and set in virtually impenetrable coils.

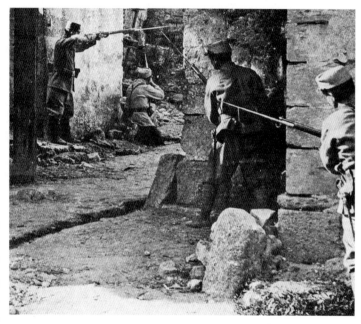

The Allied offensives of 1915 had been sobering to the British and French commanders. On 6 December they met in conference at Chantilly near Paris to discuss what they could do in 1916 to break the deadlock. It was decided that the answer was a huge combined offensive on three fronts – Western, Eastern and Italian – that would overwhelm Germany's defensive capabilities and achieve better results than unilateral, local attacks in individual sectors. The French and the British, after much debate over location, chose to launch their 'big push' around the River Somme (the junction between the British and French

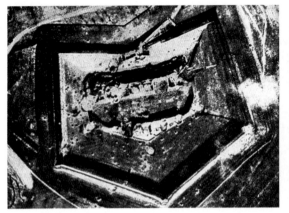

armies). It was an ambitious plan involving thirty-nine French divisions and twenty-five British divisions, and was scheduled for August 1916.

A lesson that commanders forget at their peril is that while they are making plans, the enemy is doing likewise. Falkenhayn, the German Chief of Staff, believed that the Western Front was likely to be the front that decided the outcome of the war. Although his opinion often clashed with that of Hindenburg and Ludendorff, in 1916 he switched the German focus firmly back to the British and the French. Taking attritional warfare to its logical extreme, Falkenhayn proposed drawing the French into a battle

that would 'bleed France white'. In other words, the battle was not for ground, but for cost. Falkenhayn hoped that by crushing the French spirit of resistance, the British would realize the futility of keeping going. He also hoped that the attack would disrupt Allied offensive plans for 1916.

Falkenhayn chose for his battleground the area around the fortified city of Verdun, south of the intended Somme battlefield. By assaulting Verdun with the German 5th Army, he intended to draw in massive French reinforcements, which could then be slaughtered by artillery (he assembled 1,400 guns for the assault).

The Verdun offensive began on 21 February 1916, prepared by a nine-hour artillery bombardment, and it became one of the bloodiest battles in all human history. From February to July the Germans drove the French back a distance of several miles, even taking the powerful fort at Douaumont, a huge symbolic blow to the French. As Falkenhayn predicted, the French poured in reinforcements to stem the tide, with troops, weapons and supplies flowing down the single road between Bar-le-Duc and Verdun, known to history as the *Voie Sacrée* (Sacred Way). Verdun did not fall, however, and during the autumn the French also managed to retake lost ground. The problem for Falkenhayn was

General Douglas Haig remains one of the most controversial commanders of World War I. He personally presided over campaigns that cost British forces 2 million casualties. (Library of Congress (George Grantham Bain Collection); www.gwpda. org/photos)

that Verdun was becoming as much a battle of attrition for the Germans as it was for the French. The French counter-attacks brought the German campaign to a close by 18 December, by which time each side had lost more than 300,000 casualties.

Falkenhayn's battle plan had not worked, but it did affect the Allied plans for the Somme. The British would now have to shoulder more responsibility for the Somme

campaign, and to take pressure off the French it also became a priority to launch the offensive earlier than planned. So it was that from 24 June 1916, 1,500 British and French artillery pieces spent a week drilling 1.7 million shells into the facing German lines. The British commander was General (later Field Marshal) Sir Douglas Haig, a powerful, focused character who had a very traditional approach to battlefield tactics. It was predicted that the initial artillery storm would both kill the German defenders and cut the enemy barbed wire, at which point the British soldiers would simply walk across and take their objectives against light resistance.

As history now knows, the plan was a terrible distance from the reality. The shells did not cut the barbed wire, and 30 per cent of the munitions fired did not explode

As a matter of fact we have to take special precautions during a battle to post police, to prevent more unwounded men than are necessary from accompanying a wounded man back from the firing line.
Douglas Haig, from his private papers

Did you know?
History has made much of the walking soldiers at the Somme, but part of the reason was the need to keep heavily laden men together in coherent units, something difficult to achieve in the days before mobile communications.

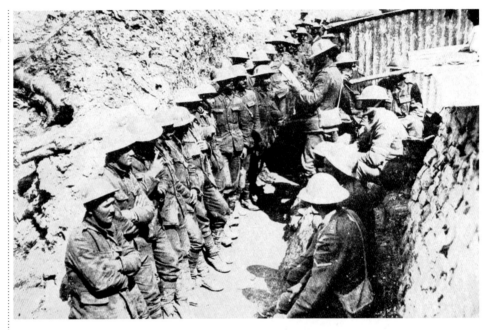

anyway. The German defenders, while certainly undergoing a horrific experience that killed and wounded many, were far from helpless as the barrage stopped on 1 July 1916. The dazed defenders moved quickly from their bunkers to see

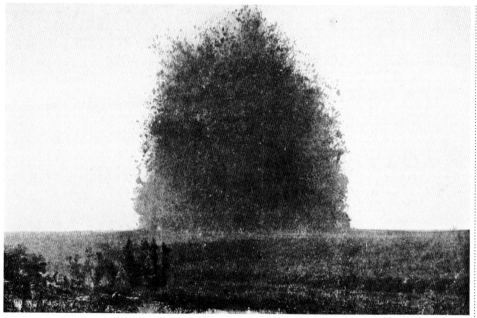

◁ *A huge British underground mine explodes beneath German lines at Beaumont Hamel during the Battle of the Somme. Some later British mine detonations were so loud they were heard in London. (*The Battle of the Somme: The First Phase, *Thomas Nelson & Sons, London, 1917; www.gwpda.org/photos)*

tens of thousands of British and French soldiers advancing across no-man's-land in a 20-mile (32km) front. The Germans set up their machine guns and went to work. The French sector of the Somme offensive actually met with a good deal of

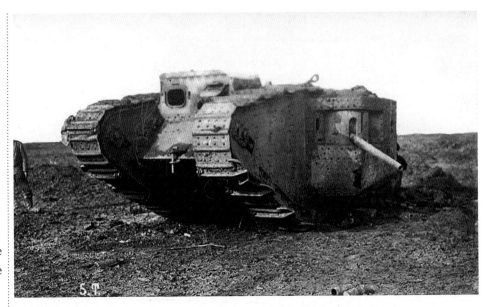

A British Mk IV tank, one of the main types of British armour used during the war. At the side we see its 6pdr gun, for which there were 180 high-explosive shells stored inside. (Copyright Walter Maier (grandson); www.gwpda.org/photos)

Did you know?

Tank crews would wear face masks made from metal links; these protected them from clouds of razor-sharp metal splinters that puffed inside the tank when bullets struck the outside.

success. With better artillery support and more nimble tactics, the French 6th Army exceeded its Day One objectives on 1 July. The British, however, suffered 19,240 dead on the first day alone, and more than 38,000 wounded. Such losses in such a time frame were, and remain, the greatest in British military history, but the advances

were measured in a matter of yards, if they were in fact measurable at all. (The greatest distance advanced on the first day was about a mile, through the villages of Montauban and Mametz.)

But this was just the beginning. The Battle of the Somme would continue until November 1916, when exhaustion and winter weather brought the front to a standstill. The battles fought during the

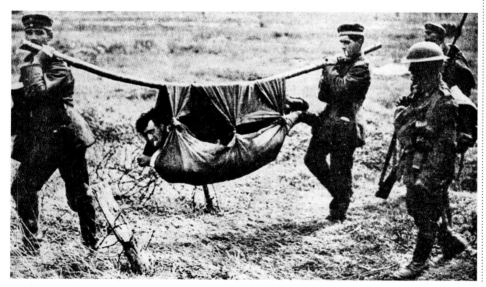

◄ A wounded Canadian soldier is carried from the French battlefield by German prisoners. A total of 67,000 Canadians died in the war, and 173,000 were wounded. (The Book of History – The World's Greatest War, Vol. XIIII, The Grolier Society, New York, 1920; www.gwpda.org/photos)

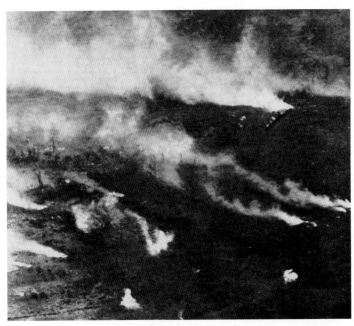

▲ *An aerial photograph shows a sector attack on the Somme in September 1916. Poison gas drifts across the battlefield, released from cylinders, although artillery shells could also deliver gas in a liquefied form. (The Story of the Lafayette Escadrille, Small, Maynard & Co., Boston, 1921; www.gwpda.org/photos)*

Somme campaign now have legendary names – Delville Wood, Thiepval Ridge, Pozières, Beaumont Hamel, to name but a few. When the battle finally ceased, the Allied frontline bulged out about 5 miles (8km) further forward than the original positions in July, but that advance had cost 660,000 Allied casualties. Ironically, although the Germans had to indeed shorten their lines in response to the Somme

offensive, the resulting positions, known as the Hindenburg Line, were actually stronger than those they had held before. One further point that should be noted is that tanks, more specifically the British Mk I tanks, made their first appearance in combat at the Somme. These curious, lozenge-shaped creatures, manned by crews who had to endure horrifying fume-filled heat inside, were woefully unreliable and could be destroyed by a single artillery shell. Yet those few that actually penetrated enemy lines caused significant disruption and damage, and after they were first used in mid-September 1916 Haig ordered 1,000 more.

The battles of Verdun and the Somme were horrendous low points on the Western Front, costing well over a million casualties in a single year. At this point we might expect a comprehensive revision of strategies and tactics, but it was largely business as usual. The war had changed, however, at least politically. On 5 December 1916 the British Prime Minister, Herbert Asquith, resigned from his position, which was duly filled by the former Secretary of State for War, David Lloyd-George. Although Lloyd-George had a healthy suspicion of Haig, who showed no compunction over the Somme disaster, and the Chief of the General Staff Sir William Robertson, there were no major command changes.

In France, by contrast, Joffre was replaced by Robert Nivelle, former Commander-in-Chief of the French 3rd Army at Verdun, who had pioneered more successful tactics in the latter stages of that battle (particularly the use of the creeping barrage). Nivelle proposed a short, furious offensive of such

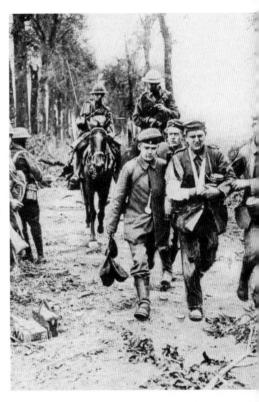

*Canadian cavalry troops escort German prisoners. It is often forgotten that in battles, such as those at the Somme and Ypres, the Germans generally sustained casualties as great as those of the Allied forces. (*War of the Nations, *New York Times Co., New York, 1919; www.gwpda.org/photos)*

force that it would bring the war to an end within two days. The main effort would be focused on the Aisne, while the British made a powerful diversionary thrust at Arras. There was considerable opposition to his plan from many quarters, British and French, but he managed to secure the approval of Lloyd-George. Nivelle got his way, although he was risking much. French manpower was struggling to cope with the continual losses, and there was a whiff of mutiny in the air.

Did you know?
France's war had an enormous effect on its economy. Government expenditure went from the equivalent of 2.2 billion dollars in 1914 to 12.3 billion dollars in 1918.

On 9 April, after three weeks of preliminary shelling, the British 3rd Army, heavily supported by Canadian and ANZAC forces, launched its offensive at Arras. True to form, there were early successes. The Canadians captured the obstinate Vimy Ridge on the first day, attacking in the wake of a skilfully handled creeping barrage. (They had also used tunnels to deploy to the frontline, to avoid German shellfire.) The British also surged forward,

A German artillery observation post in Mametz Wood stands destroyed amongst trees shattered by Allied shells. Such elevated posts were highly vulnerable to snipers and shellfire. (Illustrated War News, Vol. 1, Illustrated London News and Sketch, London, 1916; www.gwpda.org/photos)

> We had not sufficient high explosives to lower the enemy's parapets to the ground... The want of an unlimited supply of high explosives was a fatal bar to our success.
>
> Charles à Court Repington, *The Times*, May 1915

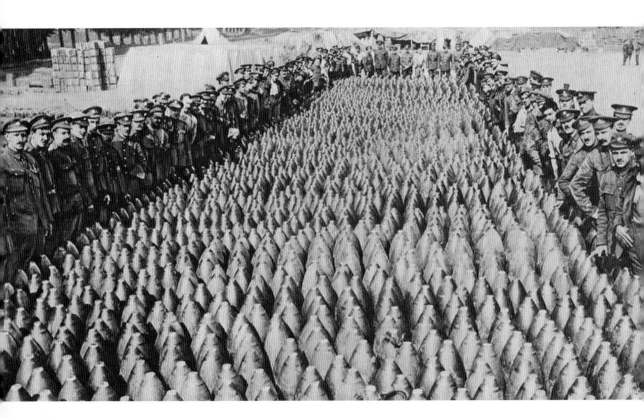

and managed an advance of up to 3 miles (5km) in places, the greatest single-day advance since late 1914. By mid-April, however, the familiar story was told. The muddy battlefield and heavy snowfalls slowed movement, as did a strengthening German defence, and the offensive ceased on 15 April.

The next day, Nivelle's offensive on the Aisne River began, thrusting forward two French armies (5th and 6th) with two more armies in reserve and support roles. Despite its scale and ambition, the Nivelle Offensive was an unbridled disaster. Munitions shortages limited artillery support and even at one point halted the attack. German defences were formidable (the Germans had received advance information about the offensive) and German artillery pounded the French troops from the outset. A section of the Hindenburg Line was captured, but by the time the French Prime Minister Raymond Poincaré halted further attacks on 23 April, the French had lost 187,000 men for a few hundred yards' advance.

The Nivelle Offensive not only ended Nivelle's career, and brought his replacement as French Army Commander-in-Chief by Henri-Philippe Pétain, but

◀ *British soldiers stand around an impressive stock of artillery shells. The shortage of such ammunition in 1915 created a political storm in Britain, which contributed to the resignation of the British Prime Minister, Herbert Asquith. (*New York Times, *01/27/1918; www.gwpda.org/photos)*

British stretcher bearers lie dead amidst the ruins of Péronne, France. Stretcher bearers had a dreadfully low life expectancy on the Western Front, and were often targets for snipers. (War of the Nations, New York Times Co., New York, 1919; www.gwpda.org/photos)

insurrection and disobedience. Although the French authorities did clamp down on the mutineers – more than 27,000 were punished or court-martialled and 449 executed – Pétain focused more on improving conditions for his men, particularly in terms of rest and food, and on limiting offensive actions to smaller, more tactically efficient operations. Such changes seemed to bear fruit when, in August 1917, a French attack around

it also stoked the mutinous spirit in the French forces. The appalling campaign conditions for French troops, and the dreadful level of casualties for no gain, resulted in some mass and many minor acts of mutiny. In one instance, 30,000 troops refused to take orders, and in total sixty-eight divisions reported instances of

Did you know?

The basic Mk I 'male' tank had a crew of eight, a top speed of just 4mph (6.4km/h), two 6pdr cannons and four .303 Hotchkiss machine guns. Maximum armour depth was about 0.47in. (12mm).

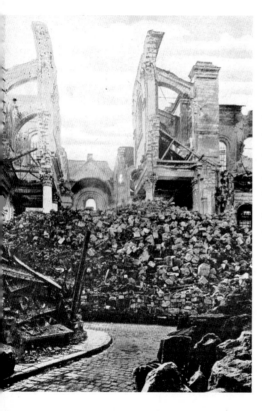

Verdun drove the Germans out of all their 1916 gains in that sector.

With the end of the Nivelle Offensive, the bulk of the fighting on the Western Front in 1917 remained in the hands of the British. The Arras campaign resumed for a month from the end of April, but with its conclusion Haig looked for further aggressive opportunities. His first objective was the Messines Ridge, on the south of the Ypres Salient, which on 7 June was ripped open when nineteen huge

> We were marooned in a frozen desert. There was not a sign of life on the horizon and a thousand signs of death.
>
> War poet Wilfred Owen, in a letter to his mother, February 1917

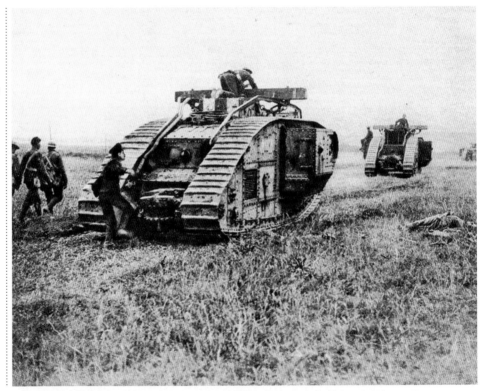

*British tanks roll into action, maintaining a steady 4mph (6.4km/h). By this point in the war, the French were also deploying tanks on a significant scale, although the effectiveness of all armour was limited by mechanical issues. (*War of the Nations, *New York Times Co., New York, 1919; www.gwpda.org/ photos)*

underground mines, dug by the Allies up to 100ft (32m) below the German lines, detonated in blasts that were heard in London and killed some 10,000 German soldiers in an instant. The shock of the explosions and the subsequent artillery barrages and infantry attack brought the Messines Ridge into British hands on the first day of the attack, and the Allies dug new defensive lines further east.

Just a few weeks later, on 31 July, the British began a broad attack at Ypres using the 2nd and 5th Armies, plus a flank support attack by the French 1st Army. After some ground was taken, the battle devolved into an episode of attrition that shocked even a war-hardened public and high command. Late summer and autumnal rains turned the battlefield into a choking quagmire, which in itself would claim thousands of lives just through drowning. Assaults along the Menin Road and towards the now infamous village of Passchendaele brought horrifying losses for gains measured in yards, although in balance German casualties were also high (26,000 on 4 October alone). A change in strategy in September, which focused more on powerful attacks on narrow fronts, did not break the situation, and the offensive was wound up in the first week of November with 245,000 British casualties, most of them killed and wounded in a futility that even Haig could not ignore.

A more convincing attempt to try something different came later in the month at Cambrai. This new British offensive, largely conceived by the nascent Tank Corps, put a force of nearly 400 tanks in the vanguard, attacking without a preliminary

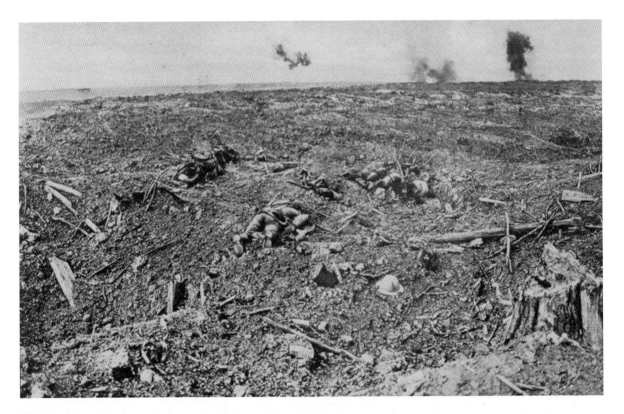

bombardment so as to achieve the element of surprise. This they did, and the offensive, launched on 20 November, made incredible advances for the times – 3rd Army pushed on 5 miles (8km) in one day. Such was the scale of the advance that church bells were rung throughout Britain. Yet the celebrations were premature. The failure of Britain to maintain the flow of reinforcements, coupled with a powerful German counter-attack on 30 November, meant that during November most of the gains were lost. Thus, adding another futile 45,000 casualties to each side, a grim culmination to two years of particularly wanton death and destruction. The year did end with one major encouragement for the Allies – the United States was now on their side.

Bodies lie shattered across the Cambrai battlefield in 1917. This photograph shows how shell holes and dips in the ground provided virtually the only cover in no-man's-land. (War of the Nations, New York Times Co., New York, 1919; www.gwpda.org/photos)

The use of tanks was one of the great technological innovations of World War I, but it was not the only one. The war at sea and particularly in the air saw the introduction of machines that would ultimately reshape the nature of armed conflict itself. Furthermore, developments in the naval war would help bring the

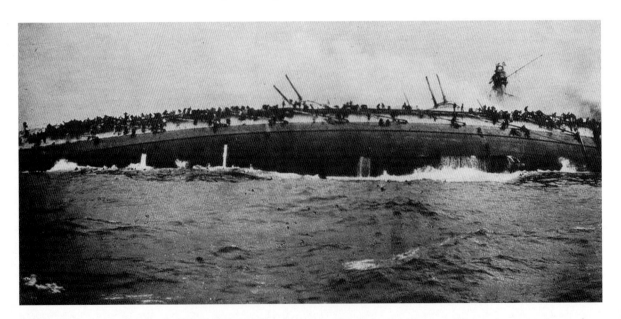

United States into the war on the British and French side.

The war at sea was just as important as the battles on land, for several key reasons. Britain in particular, an island nation, was acutely dependent upon merchant shipping for the import of food and military supplies, especially from the United States, and also for supplying its own troops in European and more distant theatres. It could also use its powerful surface fleet offensively, to blockade food and raw materials flowing into Germany through the Baltic. (In this latter objective Britain was quite successful, inflicting some serious food shortages in Germany from late 1916.) Germany, conversely, could use its navy to attack Britain's trade routes, as well as open up its own.

At the beginning of the war, the British had a significantly larger surface fleet than the Germans – it had built thirty-two major capital warships between 1906 and 1914, compared to Germany's twenty-three. The

Did you know?

The German U-19 class of submarine had four 50cm torpedo tubes and one 8.8cm deck gun. The typical effective range of the torpedoes was around 900yds (800m).

◄ The German battleship SMS Blücher rolls over onto its side as it sinks during the Battle of Dogger Bank on 24 January 1915. The battle was a British tactical victory, although the Royal Navy had two warships severely damaged. (War of the Nations, New York Times Co., New York, 1919; www.gwpda.org/photos)

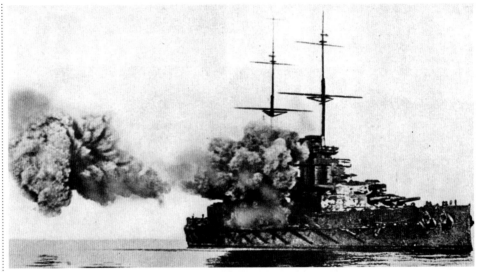

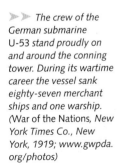

first months of the war saw aggressive patrolling by warships, attempting to prey on each others' merchant vessels, and some significant naval engagements. At the Battle of the Falkland Islands on 8 December 1914, for example, the German Far Eastern Squadron was effectively destroyed in the South Atlantic. It soon became clear that surface clashes were a risky business, and as the British put a maritime blockade in

place in the North Sea, Germany sought to wage war by other means.

The German High Seas Fleet had only twenty-eight submarines in service in August 1914, but some early successes with these vessels suggested a greater importance. On 4 February 1915, therefore, Germany committed its U-boats to 'unrestricted' operations around the British Isles. In essence, this meant that any maritime traffic sailing to or from Britain could be sunk without warning. The policy was in defiance of international 'Prize Regulations', which stated that targeted merchant vessels were first to be stopped, inspected and, if the ship was to be sunk, the crew and passengers evacuated.

After a slow beginning, the first unrestricted submarine campaign against Britain steadily brought more impressive

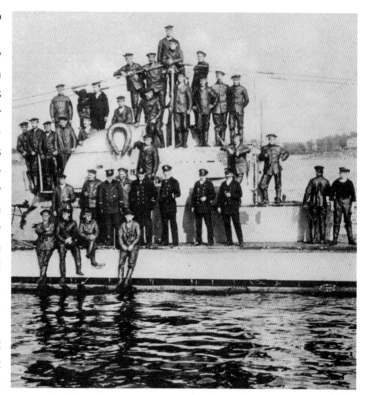

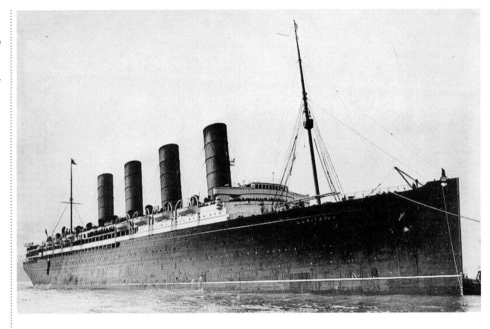

➤ The ocean liner Lusitania, *sunk by the German submarine U-20 on 7 May 1915. The U-boat's commander, Kapitänleutnant Walther Schwieger, was killed in September 1917 when his vessel,* U-88, *struck a mine. (Library of Congress; www.gwpda. org/photos)*

returns, with sinkings rising with the number of U-boats built and deployed. A total of 748,000 tons of Allied shipping was sunk, raising the prospect for a German blockade of Britain. Unfortunately for the Germans' long-term war, the submarine campaign

> *It looks as if the ship will stay afloat only for a very short time... I couldn't have fired another torpedo into this mass of humans desperately trying to save themselves.*
> From the war diary of Kapitänleutnant Walther Schwieger, commander of *U-20*, after torpedoing the *Lusitania*

also brought the ire of the United States. The United States, under the leadership of President Woodrow Wilson, took a position of determined neutrality at the beginning of the war, and would maintain this stance until 1917. Yet US trade relations undeniably favoured the Allies, and US merchant vessels became potential and actual targets of the German submarine campaign. American lives began to be lost in the Atlantic and around Britain, most notoriously in the sinking of the Cunard liner *Lusitania* off the Irish coast on 7 May 1915. Some 1,201 civilians died, including 128 Americans, and the violent protest from America meant that Germany brought its unrestricted submarine campaign to a close in September 1916, at least in Northern Europe (it continued in the Mediterranean, to powerful effect). The bonds keeping the United States tied to neutrality, however, were weakening.

With the submarines working under restrictions again, Germany looked to its surface warships for more decisive action. The new commander of the High Seas Fleet, Admiral Reinhard Scheer, increased naval bombardments of English coastal towns. At the end of May 1916, he upped the ante by attempting to draw the British

Battlecruiser Squadron out into a major surface battle against numerically superior German forces. The actual result was the Battle of Jutland (31 May–1 June), in which the full might of both the British and German fleets locked swords in an epic gun

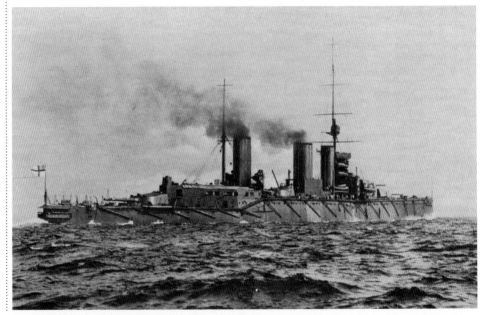

⯈ *HMS* Queen Mary, *one of the Royal Navy's great battlecruisers, was commissioned into service in 1913 but was destroyed by the German warship* Derfflinger *at the Battle of Jutland. (*War of the Nations, *New York Times Co., New York, 1919; www.gwpda.org/photos)*

battle off the coast of Denmark. Fourteen British and eleven German warships were sunk in the duel, but for practical purposes the battle was a British victory, as it was better placed to ride out the losses and maintain its blockade operations.

Frustrated, the German military commanders returned to the idea of unrestricted submarine warfare, despite the reticence of the Chancellor, Theobald von Bethmann-Hollweg, who was justifiably concerned about US entry into the war. Statisticians and economists had crunched numbers and claimed that such a campaign would push Britain to its knees. This belief was bolstered by the successes of the restricted campaign alone, so on 31 January 1917 the gloves came off again.

In terms of sinking ships, the unrestricted submarine campaign was a great success – nearly 4 million tons of Allied shipping went to the bottom of the sea in the first half of 1917. U-boat numbers were also increasing, with more than seventy U-boats deployed at any one time. The Allies, however, improved their anti-submarine tactics and technologies, and their adoption of the convoy system in May 1917 kept

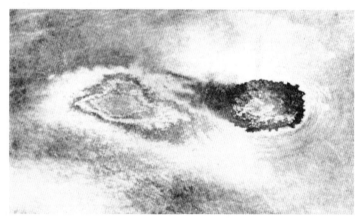

A patch of oil rises to the surface, indicative of a German submarine below being sunk. Between 1914 and 1918, a total of 204 U-boats were lost in action. (The Crisis of the Naval War, Cassell & Co., Ltd. 1920; www.gwpda.org/photos)

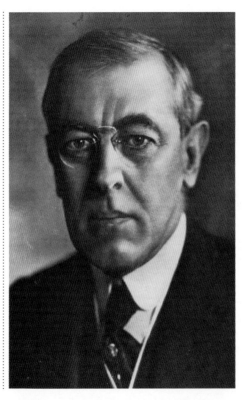

A portrait of the US President Woodrow Wilson. Wilson was initially firmly against the United States becoming embroiled in a European war, but his hand was forced by German actions in 1917. (War of the Nations, New York Times Co., New York, 1919; www.gwpda.org/photos)

losses within manageable limits. Losses declined during the second half of the year and plunged in 1918, although the Germans clung to their belief that the campaign could be decisive.

And decisive it was, but in reverse. US opinion was outraged by the campaign, and compounded by a scandal that emerged in March 1917. In January, the German

Did you know?
The convoy system worked by moving a large number of ships in a single concentration, protected by escort vessels. The convoys increased the statistical likelihood of U-boats failing to detect each Allied ship crossing the Atlantic.

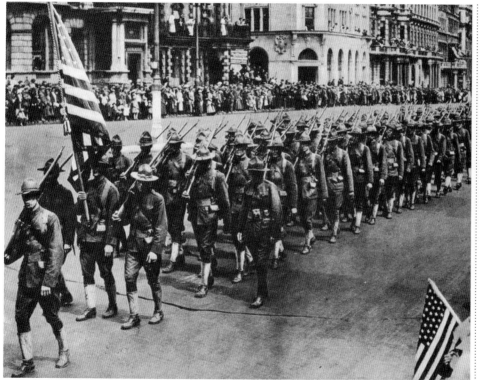

◁ US troops march through Piccadilly, London, shortly after the American declaration of war against Germany. Such troops were a welcome addition to the exhausted Allied forces. (War of the Nations, *New York Times Co.*, New York, 1919; *www.gwpda.org/photos*)

Foreign Secretary, Arthur Zimmerman, had sent a telegram to German ambassadors in Mexico City. Knowing that the United States could possibly enter the war, the Germans proposed that Mexico open a German-sponsored war against the United States, in return for territories lost to the Americans in the previous century. British naval intelligence obtained the telegram and made the contents known to the US government. Combined with the relaunch of the unrestricted submarine campaign, the telegram was the final straw. On 6 April 1917, the United States declared war on Germany. It would take some time for the nation to mobilize its vast economy for war. The first American troops arrived in the European theatre in June, but it was in 1918 that the US war machine would help deliver the knockout punch.

Stepping back temporarily from the great strategic moments of the war, it is worth exploring a new development in the way that the war was fought. Powered aviation was only just over a decade old by the time that the war began, but the world's militaries had already invested in small air forces, particularly the French. Most of the planes deployed were unarmed, slow-moving monoplanes, biplanes and triplanes, and at the outbreak of war in 1914 their combat potential was negligible. They were useful, however, for performing aerial reconnaissance, the air crews providing insight (and photographs) concerning enemy manoeuvres and fire control for artillery. (Observation balloons were also used for this purpose.)

Gradually the importance of these 'eyes in the sky' became clear to both sides, and

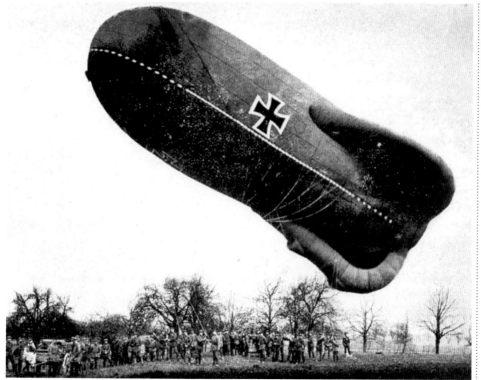

A German observation balloon lumbers into the air. Shooting down such balloons was one of the reasons why fixed-wing combat aircraft were developed. Aircraft also provided more versatile reconnaissance platforms. (The German Air Force in the Great War, *Hodder & Stoughton, London, 1920; www.gwpda.org/photos)*

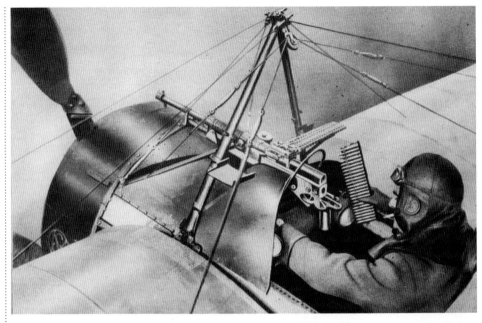

hence so did the need to destroy the enemy aircraft with purpose-built fighters. At first aircraft were 'armed' by nothing more than a pilot or co-pilot carrying small arms, the aviator taking pot shots at the enemy aircraft, with unlikely prospects of any

mounted directly on the engine cowling in front of the pilot, firing safely through the propeller by means of an interrupter gear. Now the pilot could shoot where he looked.

The new armament configuration, quickly adopted by all airborne combatants, led to the birth of fighter warfare. Aircraft such as the British Sopwith Camel and SE5A, the German Albatross DIII and Fokker DVII, and the French Spad XIII, were soon locked in 'dogfights' over the Western Front in a struggle for air superiority. They were also used in ground-attack roles such as light bombing and strafing runs. Life expectancy for the fighter pilots was horribly short, often measured in just days from arrival with their squadron. Yet some survived as 'aces' with numerous 'kills' under their belts, men such as Georges Guynemer (France), Manfred

The Nieuport 17 flew in both French and British service, and was typical of the fighter aircraft of World War I. It had a top speed of 103mph (165km/h) and a service ceiling of 17,400ft (5300m). (The Story of the Lafayette Escadrille, Small, Maynard & Co., Boston, 1921; www. gwpda.org/photos)

decisive hit. Machine guns were then fitted, typically on the top wing or rear-facing to avoid the prospect of shredding the propeller. Yet during 1915, the mechanical innovations of engineers and aviators such as Raymond Saulnier, Roland Garros and the Fokker company led to machine guns

von Richtofen (Germany; the infamous 'Red Baron') and Albert Ball (Britain).

World War I not only gave birth to fighter warfare, but also to the concept of strategic bombing. Although they stretched against the contemporary possibilities of aircraft design, several heavy bombers emerged from the war, such as the Handley Page O/400 and the Zeppelin-Staaken RVI. They were lumbering and easy targets for fighters, but they had decent bomb

Did you know?

Zeppelin airships had incredible powers of endurance. One such craft, *L59*, made a journey of more than 4,000 miles (6,400km) in an attempt to resupply German troops in East Africa.

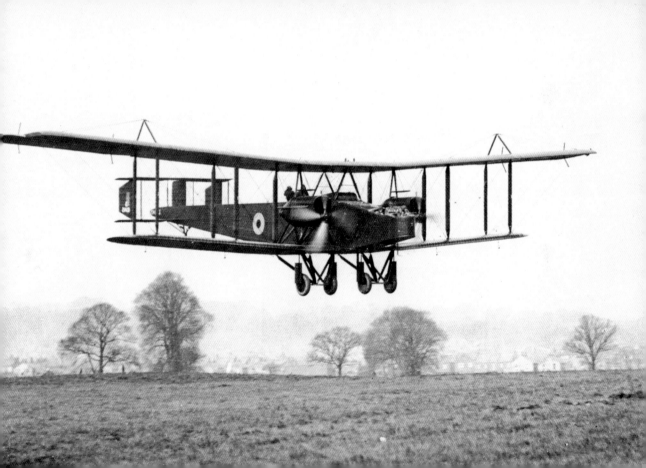

The Germans were not the only nationality to use airships during World War I. Here we see some British examples – British airships were primarily used for spotting and attacking German U-boats. (War of the Nations, New York Times Co., New York, 1919; www.gwpda.org/photos)

An evocative image over Compiègne, northern France, shows the trail of smoke left by a German Zeppelin shot down by French anti-aircraft artillery. Airships were particularly vulnerable to incendiary shells. (The Story of the Lafayette Escadrille, Small, Maynard & Co., Boston, 1921; www.gwpda.org/photos)

loads – the RVI could carry up to 4400lb (2000kg) of ordnance – and had a powerful shock effect on those attacked. Germany launched a strategic bombing campaign against Britain that not only used such fixed-wing aircraft, but also the majestic Zeppelin dirigibles. The first Zeppelin raid on London, on 31 May 1915, killed twenty-eight people and wounded sixty. The worst civilian casualties from the German campaign, however, came on 13 June 1917, when Gotha bombers caused 158 dead and 425 wounded in the capital.

Air power became a significant additional tool in the warfighter's box during World War I, although its actual effect on the war's outcome was minimal. What the conflict did was to establish the combat role of aircraft, a role that would become central to the outcome of the following world war.

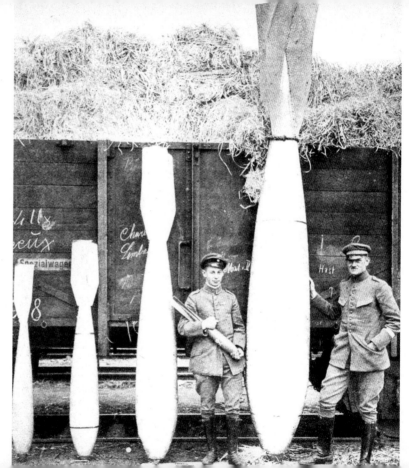

German soldiers pose by the side of a variety of aerial bombs. The specimen on the far right weighed 1 metric tonne, and could only be carried by the heaviest airships or bombers. (The German Air Force in the Great War, *Hodder & Stoughton, London, 1920; www.gwpda.org/photos*)

As already noted, the Eastern Front was a war of manoeuvre, in contrast to the largely static affair on the Western Front. This trend continued from 1915–17, so much so that it is only possible to paint the campaign in broad brushstrokes here.

The first full year of the war was disastrous for the Russians, as their manpower and morale struggled under horrifying losses. An Austro-German offensive through the Carpathians in January–March 1915 was no easy ride for the Central Powers, both sides losing thousands of men to bullets, artillery and hypothermia in the mountainous conditions. In fact, the Russians actually recovered enough ground to prepare for an attack on Hungary. Before they could do so, however, the Germans launched an assault in Poland, the Second Battle of the Masurian Lakes, which resulted in the Russian 10th Army being virtually destroyed. The territorial gains from this offensive were minimal, but on 2 May a 700,000-shell bombardment opened a new Austro-German offensive between Gorlice and Tarnow in Galicia. Now the Russians began to crumble. Taking more than 400,000 casualties in May, they were driven out of Galicia by mid-June. A subsequent onslaught further north in July then forced them from Poland by

An Austro-Hungarian 305mm howitzer is hauled into action in the Carpathian Mountains. The nature of the terrain in the mountains made deploying the simplest support weapons into a major task. (War of the Nations, New York Times Co., New York, 1919; www.gwpda.org/photos)

Did you know?

At the beginning of the war, Russia's main strength was in its manpower resources. Yet in 1914 it lost more than a million men, and suffered another 3 million casualties in 1915.

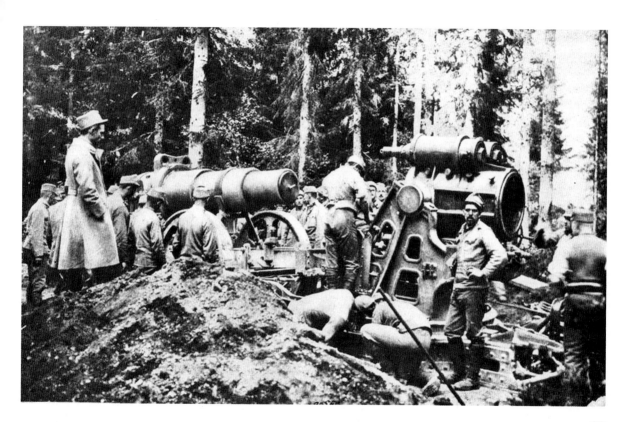

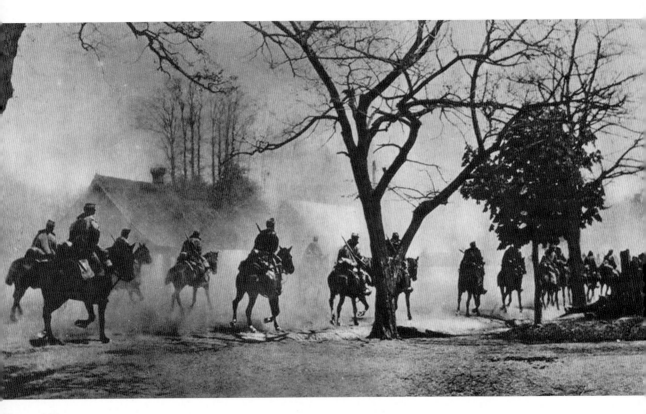

mid-September. In these disastrous months, the Russians had lost 750,000 men.

The Central Powers were also doing well in Serbia. Having failed three times to take Serbia themselves, the Austro-Hungarians went into Serbia again on 6 October playing second fiddle to the German 11th Army. This time success was had, with Belgrade falling on 9 October and the Serbian Army undergoing a harrowing retreat through Albania during November and December.

The Central Powers had every right to feel confident of victory on the Eastern Front by the end of 1915. Certainly, the Russian Army had its problems. It had plenty of manpower, but there were chronic materiel issues for everything from rifles to food.

Nevertheless, 1916 saw a reversal in Russian forces. This did not come from a Russian offensive on 18 March towards Vilna in Lithuania, which did little except cost the Russians 110,000 men. Instead it was delivered the following June by Russian general Alexei Brusilov. Brusilov was commander of the Russian Southwest Front, and he proposed an overhaul of Russia's traditional offensive tactics. Instead of a focused attack in a particular sector, which could be contained by the enemy, Brusilov advocated a broad general attack between the Pripet Marshes and the Carpathians, overwhelming the response of the German and Austro-Hungarian reserves and delivered behind an intense artillery barrage kept deliberately short to minimize warning of the infantry assault. Despite opposition to these apparently radical suggestions, Brusilov got his way, and the offensive was launched on 4 June.

Austro-Hungarian cavalry set off in pursuit of retreating Russians. The Eastern Front provided some of the few opportunities to use cavalry in their traditional assault roles. (War of the Nations, New York Times Co., New York, 1919; www.gwpda.org/photos)

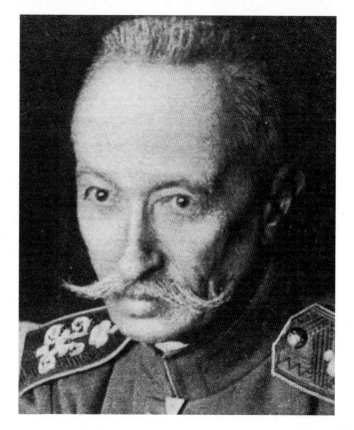

◁ *In what appears to be a clearly staged photograph, Austrian troops in the Carpathian Mountains demonstrate the correct team method of transporting a machine gun through the snowscape. (*History of the World War, *Vol. 2, Doubleday, Page & Co., 1917; www.gwpda.org/photos)*

▷ *General Alexei Brusilov, the mastermind of the 'Brusilov Offensive' of June 1916. Brusilov paid particular attention to planning artillery fire, reducing the interval between the fire lifting and Russian troops reaching the enemy lines. (*War of the Nations, *New York Times Co., New York, 1919; www.gwpda.org/photos)*

Did you know?

In 1915 the Russian Army suffered a major shortage of rifles – production was running at about 20,000 units below demand, and 2.3 million weapons had to be imported from abroad.

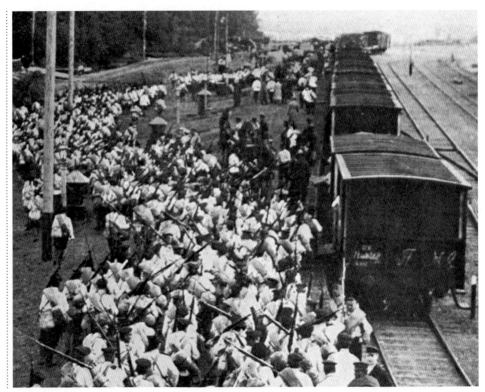

A clustering mass of Russian infantry prepares to join a train to deploy to the frontline. By the later years of the war, the Russian units were suffering from manpower shortages, poor clothing and inadequate food. (The War Illustrated Album DeLuxe, *Vol. 1*; Amalgamated Press, London, 1915; www. gwpda.org/photos)

For the first month, the attack was wildly successful. Deep advances were made into Poland and Galicia. Two of the defending Austro-Hungarian armies, the 4th and 10th, had lost 160,000 men by mid-June, and 350,000 prisoners were taken by the end of the month. German intervention came just in time, and the offensive eventually lost momentum in September. Despite its success, the Brusilov Offensive had cost the Russians nearly a million men, dead, wounded or taken prisoner. Furthermore, it made the Russian population, already expressing rebellious instincts against the rule of Tsar Nicholas II, even more restless for political change. Mass demonstrations filled the streets of Petrograd on 8 March 1917 (dated 23 February in the old Russian calendar). These expanded into the 'February Revolution', which led to the abdication of Nicholas II and the establishment of a new Provisional Government.

Despite the upheaval, the new government committed itself to continuing the war, a policy opposed by the powerful Bolshevik Party led by Vladimir Lenin. A Russian offensive in July, aimed at recapturing Lvov, was a disaster that took the Russian Army to the point of collapse.

Do not trust the promises of the Bolsheviks! Their promise of an immediate peace is a lie! Their promise to provide bread is a fraud!

Russian Prime Minister Kerensky, September 1917

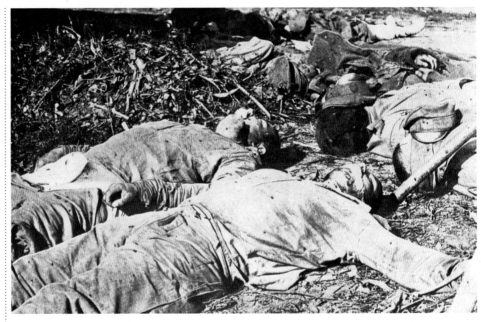

This process continued with Germany's Riga Offensive launched on 1 September. Here the German 8th Army used new tactics pioneered by its commander, Oskar von Hutier, who applied fast assault movements and mobile infantry support

weapons to punch through to enemy rear areas, causing confusion while bypassing areas of heavy resistance. The Germans were laying the foundations for the future blitzkrieg, and the offensive succeeded in capturing Riga and threatening Petrograd.

In the end, it was not necessary to take Petrograd. During the 'October

Revolution', the Provisional Government was ousted from the city by the Bolsheviks. Lenin became the new head of state, and on 15 December 1917 Armistice talks with Germany were concluded. Russia was out of the world war (although thrust into civil conflict), and Germany no longer had a two-front war on its hands.

Elsewhere in the war, events had also been moving fast. Romania entered the war on the side of the Allies on 27 August 1916. Yet Romania was sandwiched between Austria-Hungary and Bulgaria, which had joined the Central Powers on 15 October 1915, and a huge Austro-German/Bulgarian invasion crushed the nation's resistance between August 1916 and January 1917. In the Middle East, the British delivered a strong campaign in Mesopotamia, but found progress tough

Did you know?
In the Treaty of Brest-Litovsk, signed on 3 March 1918 between Germany and Russia, the territories of Poland, the Baltic States, Finland and Ukraine effectively passed into German hands, although the gains were to be temporary.

Indian troops in Mesopotamia, led by a British officer, undergo roll call. In 1916, some 11,000 Indian soldiers in the Middle East died of scurvy, until it was thought appropriate to supplement their diets with vitamin C. (War of the Nations, New York Times Co., New York, *1919; www.gwpda.org/ photos)*

going against Turkish and German troops in Egypt and Palestine. Aided by the Arab Revolt against the Turks from June 1916, however, the Turks were eventually defeated in Palestine and Jerusalem was captured on 9 December.

◁ *Austrian troops aim their rifles from a cliff-top overlooking the Isonzo River. The photograph shows how the terrain in the Italian Front clearly favoured defence rather than attack.* (War of the Nations, *New York Times Co., New York, 1919; www.gwpda.org/photos*)

The Italian Front had also been extremely lively and bloody. Italy's frequent offensives on the Isonzo Front from 1914 to mid-1916 had produced few results other than a spiralling death toll and plummeting morale. On 15 May 1916, however, the Austro-Hungarians went on the offensive against a weakened enemy. Attacking in the Trentino on 15 May, they managed at best an advance of up to 12 miles (19km) by the time the offensive spent itself by the end of June, but it had cost the Italians 147,000 men, compared to Austria-Hungary's 80,000. There was more violence on the Isonzo Front (there had been eleven Italian offensives by August 1917), and the Austro-Hungarians eventually began to weaken and seek German assistance. It came in the form of Germany's 14th Army, which on 24 October crossed the

Reinforcements were brought up from somewhere but it was hopeless. The Fifth Army was well whacked with a German division facing one battalion of our lads.

British soldier describing the German 'Michael' Offensive

Isonzo and took Caporetto, the town that gave its name to the broad Austro-German offensive into north-eastern Italy.

Weakened by years of war and bloodshed, the Italians eventually folded and were driven from their mountain defences. By mid-November, when the Italians stopped their retreat, the Central Powers had advanced up to 200 miles (320km) into Italy.

By 1918, even after more than three years of fighting, Germany appeared to be in a strong position to secure victory. Russia's retraction from the war meant that German forces in the east could be transferred to the west, giving them a slight numerical

◄ *Tsar Nicholas II attempts to inspire his troops with an icon. In 1917 he was forced to abdicate during the revolution, and was later executed, along with his family, by the Bolsheviks. (*The Clash of Nations: Its Causes and Consequences, *Thomas Nelson & Sons, New York, 1914; www.gwpda. org/photos)*

A German field telephone centre near the frontline. Field telephones provided one of the best means for immediate battlefield communications, but their lines were vulnerable to being cut by shellfire. (Library of Congress (George Grantham Bain Collection); www.gwpda. org/photos)

superiority in that theatre. Furthermore, the Germans had learnt many tactical lessons during the previous year, particularly about fire and manoeuvre, whereas the British and French were still largely focused on the attritional battles they had fought in the past.

Germany's key priority was to launch crushing offensives before the Americans could build up their presence in France.

The first, known as the 'Michael' Offensive, came on 21 March, in which three German armies (2nd, 17th, 18th) commanded by Erich Ludendorff hurled themselves against the weak British 3rd and 5th Armies on the Somme. The German supporting firepower was devastating – 6,437 artillery guns – and the advance was impressive, headed by 'Stormtrooper' soldiers using the type of assault tactics pioneered by Hutier. The 5th Army was destroyed, and by late March the Germans had advanced nearly 50 miles (80km) at the deepest point.

'Michael' was just the first of repeated, surging German offensives along the length of the Allied frontline between March and July 1917, and there were German gains in most sectors. The offensives were intended to break the Allied resistance decisively (particularly that of the British), without

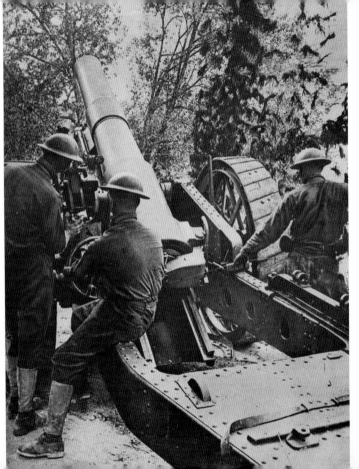

◀ *American forces brought additional hardware to the battlefields of 1918. Here US artillerymen sight their M1918 howitzer in preparation for a bombardment. (*War of the Nations, *New York Times Co., New York, 1919; www.gwpda.org/photos)*

▶ *Framed by three Maxim machine guns, a German unit poses for a photograph in 1918. Tens of thousands of German troops would die in the final offensives and in the retreats of 1918. (Copyright Walter Maier (grandson); www.gwpda.org/photos)*

giving it time to recuperate. Devastation was certainly wrought amongst the Allied troops, but the fact remained that the Allies survived, while the Germans wore themselves down with every onslaught. 'Michael' alone cost the Germans 239,000 men, and at the same time the Americans were building up their strength – by May there were 650,000 in France, and tens of thousands more were arriving each week.

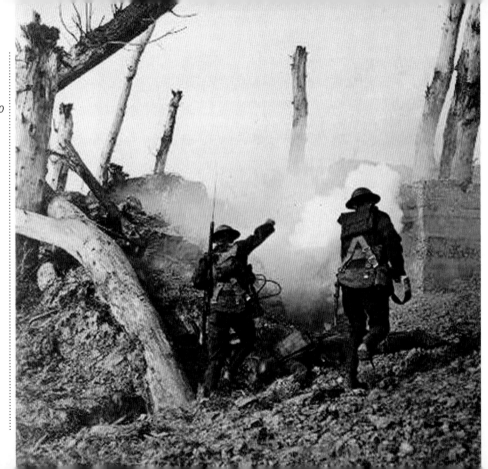

A dramatic image of US soldiers going into the attack in 1918. The United States suffered 50,000 dead and 230,000 wounded, despite its short length of service during the war. (Library of Congress; www.gwpda.org/photos)

US forces, commanded by General John Pershing, first went into action in late May, when the US 1st Division captured the German-held village of Cantigny. The US soldiers were inexperienced in combat, but they were fresh and enthusiastic, and their presence undoubtedly lifted Allied morale on the Western Front.

The Germans' final 1918 offensive, on the Marne, had gasped out of breath by mid-July. It was now that the roles were reversed. The Allies – pulling up their reserves and utilizing increasing US power – now returned a series of heavy offensives that put German forces into retreat, and on the road to defeat. The Allies were themselves using more mobile assault tactics and a better concentration of force, and tanks were committed in larger numbers and in a more intelligent manner. The first major attack, by the French and Americans on the Marne Salient on 18 July, advanced 30 miles (50km) and netted 25,000 prisoners. A British offensive at Amiens from 8 August crushed six German divisions, and during September the British/Commonwealth forces went on to puncture the Hindenburg Line, forcing a German withdrawal further north to straighten the defences. In late August, the American 1st Army committed itself in strength to an attack on St Mihiel, which achieved all its objectives, although the subsequent American offensive into the Argonne was much more arduous, and cost the US soldiers legendary losses.

Matters were now coming to a head for the Germans. Continuing offensives at Cambrai and Ypres brought more Allied gains, and total German losses for the

▶ The United States also brought impressive industrial muscle to the Allied powers in World War I. Here US soldiers stand around a pile of 85,000 tyres destined for the American Expeditionary Force (AEF). (US National Archives; www.gwpda.org/photos)

month of September alone numbered 230,000. The alliances of the Central Powers were also coming apart. Austria-Hungary, Germany's greatest ally, albeit one of dubious value, had begun a peace initiative on 15 September as its war on the Italian Front finally gave way to Italian victory. On 28 September, Bulgaria sued for peace, its army having been defeated in the Vardar Offensive in Serbia, conducted by a joint Serbian, British and French force. During the same month, the Turks were defeated and pushed out of Palestine by the British. By November 1918, therefore, Germany was largely alone.

We should not give the impression that it was purely battlefield events that dictated the last events of World War I. Political upheaval, economic crises, food shortages, ethnic tensions and despair at the human cost all played powerful roles on the home fronts. Such was particularly true within Germany, which had sacrificed 2 million of its soldiers but was now staring defeat in the face. Strikes, civil unrest and revolutionary rumblings spread throughout the country. On 29 September, Ludendorff having been incapacitated by a seizure the previous day, Germany approached the Allies about an Armistice.

Did you know?

In 1918 the horrors of war were magnified by the global Spanish Flu epidemic. It lasted until 1920, and may have killed up to 100 million people, including tens of thousands of soldiers in Europe.

➤ *A German soldier sprawls in the mud and raises his hands in an act of surrender. The German offensives of 1918, while impressive in their power and gains, were actually last gasps. (Illustrated War News, Vol. 7, Illustrated London News & Sketch, London, 1918; www.gwpda.org/ photos)*

Ypres 1915
Edmond Lecellier

◀ *Some communities paid a terrible price for being near the frontlines. This painting depicts the ruin that was the town of Ypres by the time the guns fell silent. (Courtesy of Will Fowler)*

123

Fighting continued even as Armistice negotiations were under way. At first the talks centred on President Wilson's 'Fourteen Points', a list of peace resolutions presented to the US Congress the previous January. The list of demands eventually presented by the Allies to Germany were punitive, and included regime change (the Kaiser resigned on 9 November) and large volumes of military materiel to be surrendered. Yet the Germans ultimately had no choice. The Armistice was signed by the German and Allied delegations at 5.10am on 11 November, becoming effective at 11.00am.

The guns now fell silent over Europe, the silence hanging poignantly over the millions of dead that lay in cemeteries and battlefields across the world. The total casualties of World War I will never be known with accuracy. Military deaths are likely to number around 10 million, including 1.6 million Germans, 1 million Austro-Hungarians, 1.4 million Frenchmen, 900,000 British, 1.7 million Russians and 700,000 Italians. Although civilians were not in harm's way as much as they would be in World War II, the death toll amongst

Did you know?
The Treaty of Versailles in 1919 placed Germany under hefty reparations payments and reduced its armed forces to no more than 100,000 men. They were prohibited from having combat aircraft, tanks and submarines.

Today huge cemeteries, such as this Commonwealth War Graves Commission (CWGC) site in France, remain as sobering reminders of the huge human cost of World War I. (Courtesy of Will Fowler)

them from both the fighting and the political settlements of the Versailles Treaty secondary effects of disease and starvation following the war arguably helped to lay were also in the millions. the foundations of the next world war, at

World War I was fought largely because least in providing some of the conditions of political fear and imperial friction, and for a man like Adolf Hitler to come to its futility must never be forgotten amidst power. World War I was an avoidable the rightful reverence we have for the tragedy, and a salutary reminder of where war dead. In an extra layer of tragedy, the hubris can lead.

Gilbert, Martin, *The First World War: A Complete History* (London, Phoenix Press, 2000)

Holmes, Richard, *Tommy: The British Soldier on the Western Front 1914–18* (London, HarperCollins, 2004)

Keegan, John, *The First World War* (London, Pimlico, 1999)

McNab, Chris, *The Somme: France 1916* (Andover, Pitkin Publishing, 2010)

Stone, Norman, *World War One: A Short History* (London, Penguin, 2008)

Strachan, Hew, *The First World War* (London, Simon & Schuster, 2003)

Wilmott, H.P., *World War I* (London, Dorling Kindersley, 2009)

Other titles published by The History Press

The Classic Military Vehicles Story
Chris McNab
978 0 7524 6204 2

The World War II Story
Chris McNab
978 0 7524 6205 9

Visit our website and discover thousands of other History Press books.

www.thehistorypress.co.uk